## Color your worries away!

Be more relaxed, focused, and energized! Coloring helps t̶ ̶̶̶̶̶̶ ̶al creativity.
Find your own style in the pages that follow. Here are so̶̶̶̶̶̶̶̶̶̶ ̶̶̶̶d.

## Color Theory 101

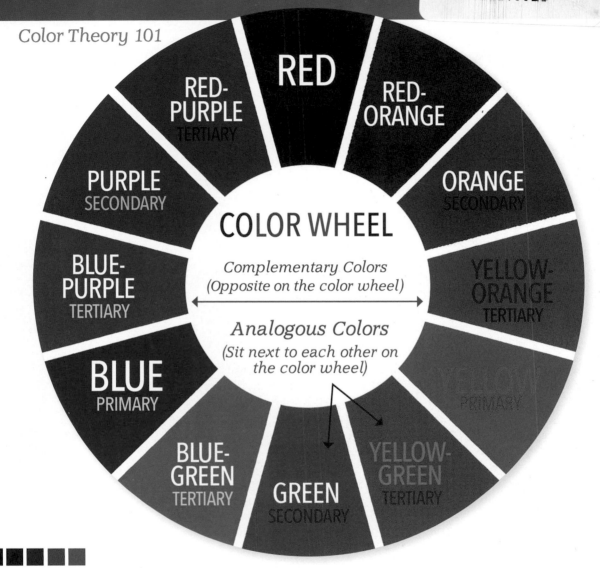

**COLOR WHEEL**

*Complementary Colors*
(Opposite on the color wheel)

←——————————————→

*Analogous Colors*
(Sit next to each other on the color wheel)

- RED
- RED-ORANGE *TERTIARY*
- ORANGE *SECONDARY*
- YELLOW-ORANGE *TERTIARY*
- YELLOW *PRIMARY*
- YELLOW-GREEN *TERTIARY*
- GREEN *SECONDARY*
- BLUE-GREEN *TERTIARY*
- BLUE *PRIMARY*
- BLUE-PURPLE *TERTIARY*
- PURPLE *SECONDARY*
- RED-PURPLE *TERTIARY*

### Warm Colors

Warm colors are vivid and energetic.

### Cool Colors

Cool colors are calm and soothing.

### Complementary Colors

Use complementary color when you want to emphasize the colors. They naturally play off one another and make each other look more vivid and intense.

### Analogous Colors

Use analogous colors when you want more than one color but want to maintain a sense of unity.

### Primary Colors

Primary colors can't be mixed or made. Different combinations of primary colors create all other traditional colors.

### Secondary Colors

Combining two primary colors together creates a secondary color.

### Tertiary Colors

Combining a primary and a secondary color results in a tertiary color. You may know them by their fancier names like "teal" or "lime green" but they are referred to by the two colors that make them up, with the primary color first.

*art* UNPLUGGED

A NATURAL SOURCE OF HEALING

*Stippling is filling in space with tiny dots—tightly packed, spread out, or however you want to place them. This can add texture and interest to your designs.*

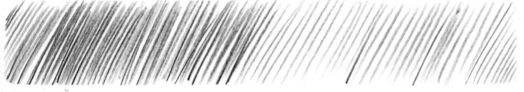

*Hatching is filling space with a series of separate parallel lines.*

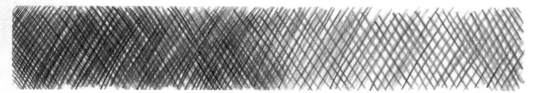

*Cross-hatching is drawing a layer of hatching and then adding a second layer of hatching in another direction, on top. It can give the illusion of depth and shading.*

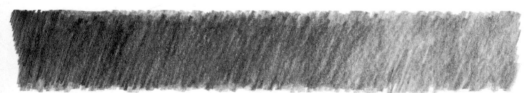

*Back-and-forth stroke ("scribbling") is a simple continuous motion to fill in space with a solid color. Do it without lifting your pencil or marker off the page.*

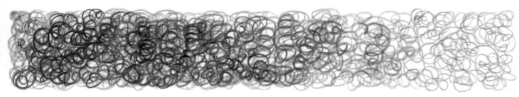

*Circular stroke is another way to fill a space with solid color: moving your pencil or marker continuously in overlapping circles.*

## Tip: Keep Your Colors Safe

*Store your colored pencils somewhere safe, where they won't be dropped or shuffled around. That will protect the lead inside your pencils and keep it from cracking, so your pencils sharpen cleanly and easily.*

# Adding Texture and Layers and Detail

*Sharp colored pencils and fine markers are great for coloring delicate details.*

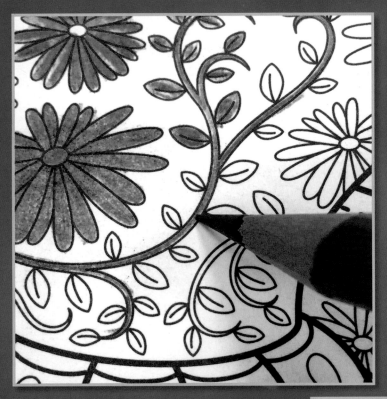

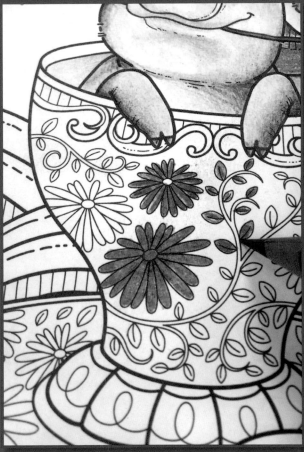

*You can add textures and depth by starting with a light color and then going back and coloring over it with a darker color, or pressing down harder with the same pencil or marker.*

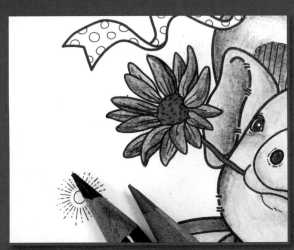

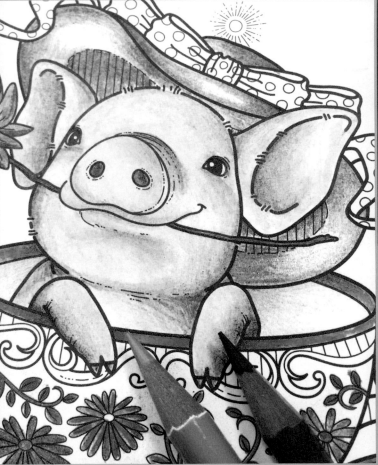

*Different colors can be blended together in a smooth transition.*

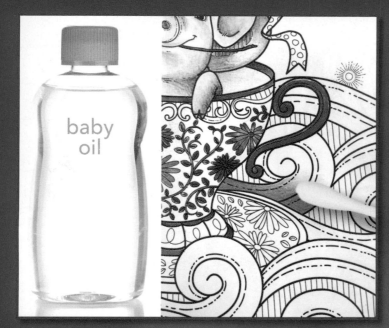

Use a cotton swab lightly dipped in baby oil to soften hard edges or smooth two blending colors together.

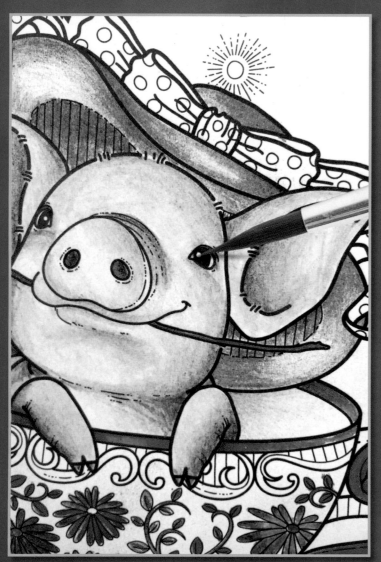

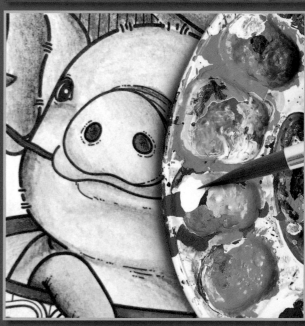

Add white highlights with a gel pen, or a fine brush with white paint, to look like light reflecting on a surface.

A NATURAL SOURCE OF HEALING

# Cats
## & kittens

*This EXPERIENCE belongs to:*

©2016 Art-Unplugged
3101 Clairmont Road · Suite G · Atlanta, GA 30329

For helpful tips, examples, and inspiration, please visit: **art-unplugged.me**

Illustrations by Marlene Minker
Design by Dana Wedman

This book is not intended as a substitute for the advice of a mental-health-care provider. The publisher encourages taking personal responsibility for your own mental, physical, and spiritual well-being.

Correspondence concerning this book may be directed to the publisher, at the address above.

**Look for the entire series of art-unplugged journals.**

ISBN:  1940899109 (Cats & Kittens)

Printed in the United States of America

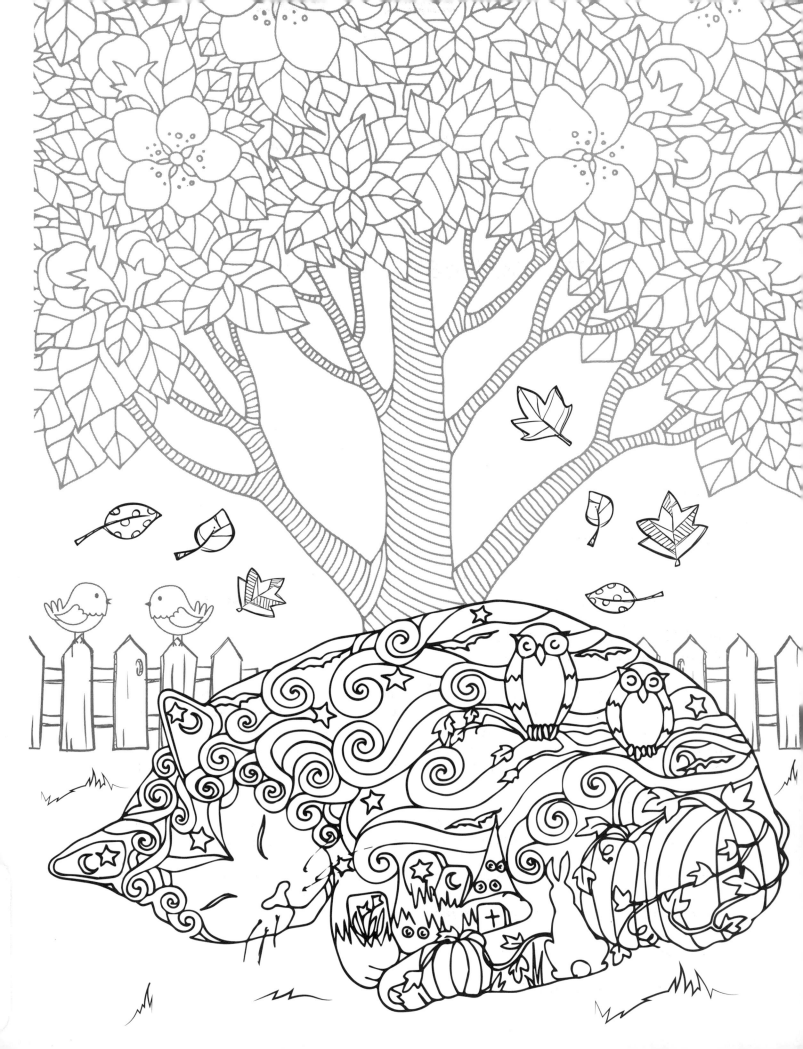

*"A cat pours his body on the floor like water."*

*–William Lyon Phelps*

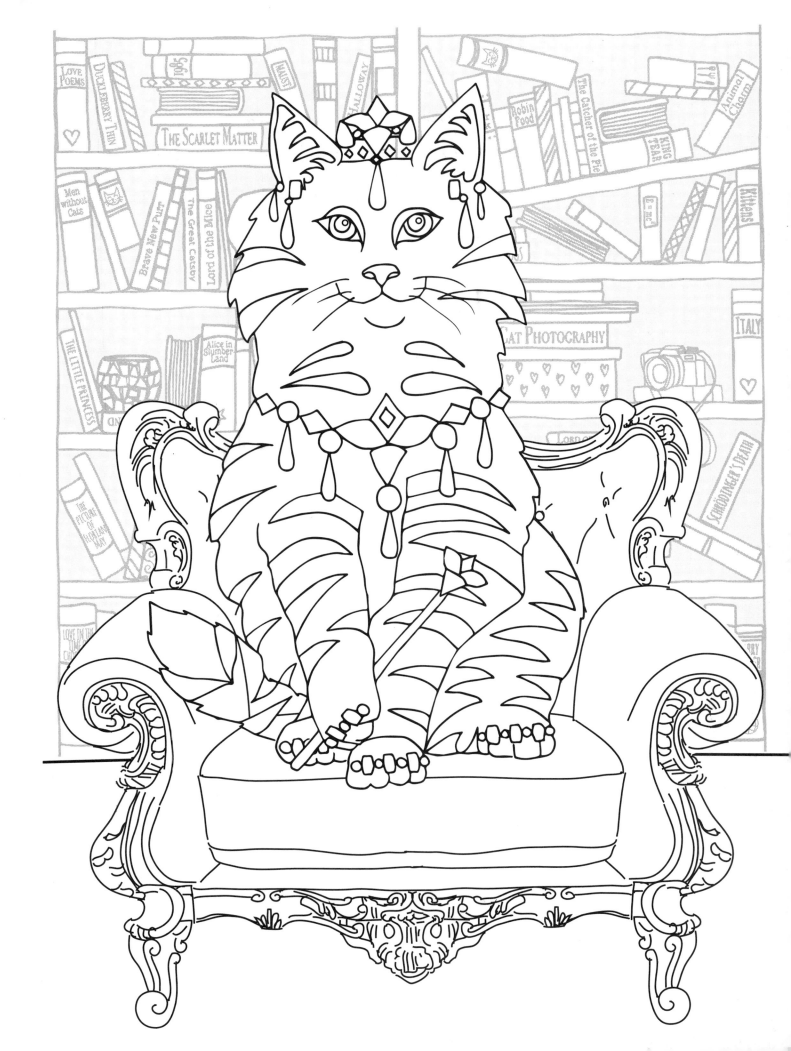

*"There are few things in life more heartwarming than to be welcomed by a cat."*

–Tay Hohoff

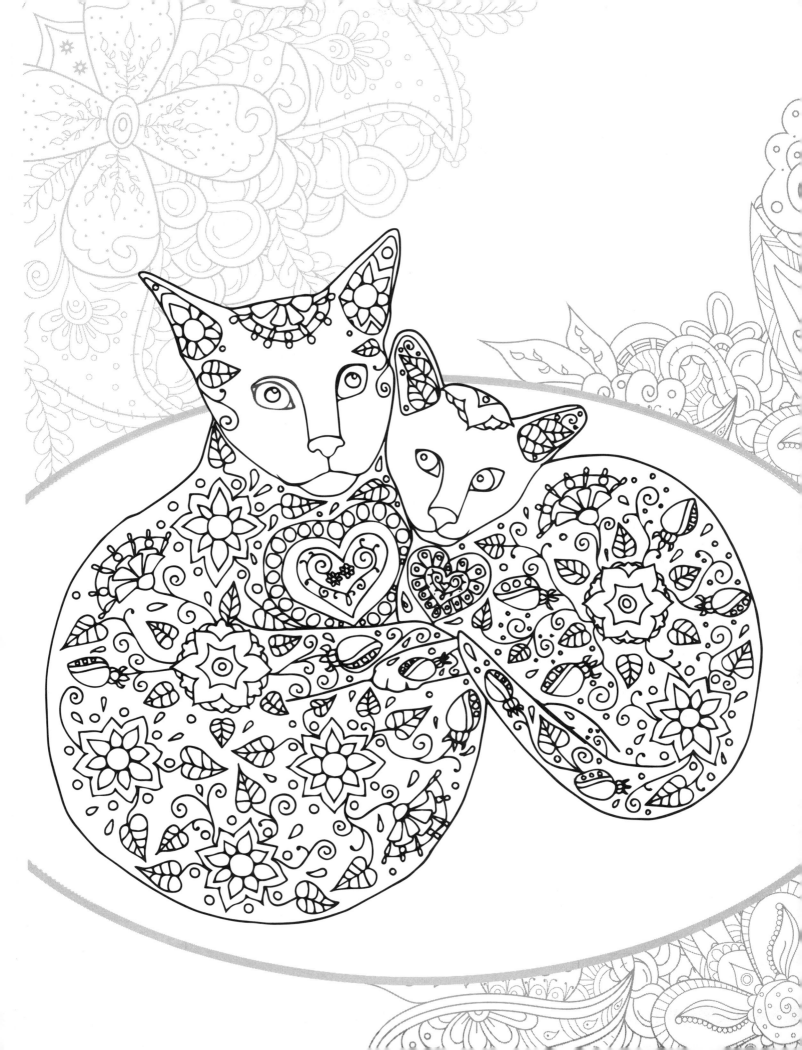

*How does this picture make you feel about your life? Are you connected in any way to the image on it?*

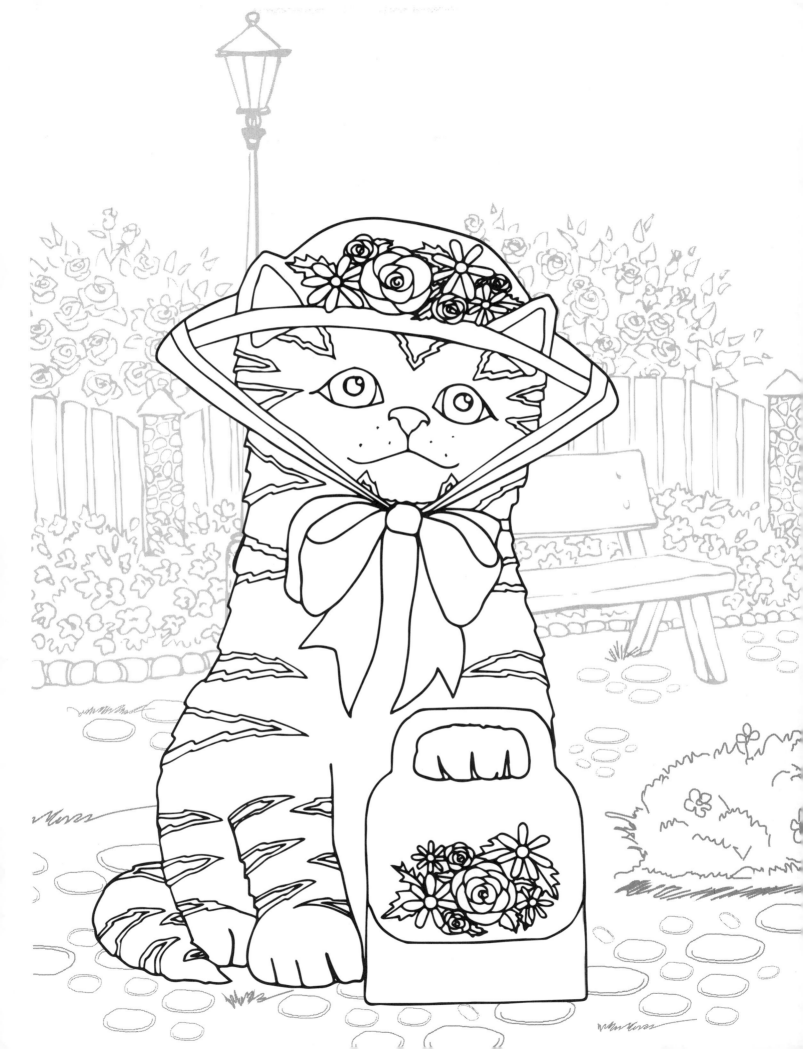

*"A kitten is the most irresistible comedian in the world."*

–Agnes Repplier

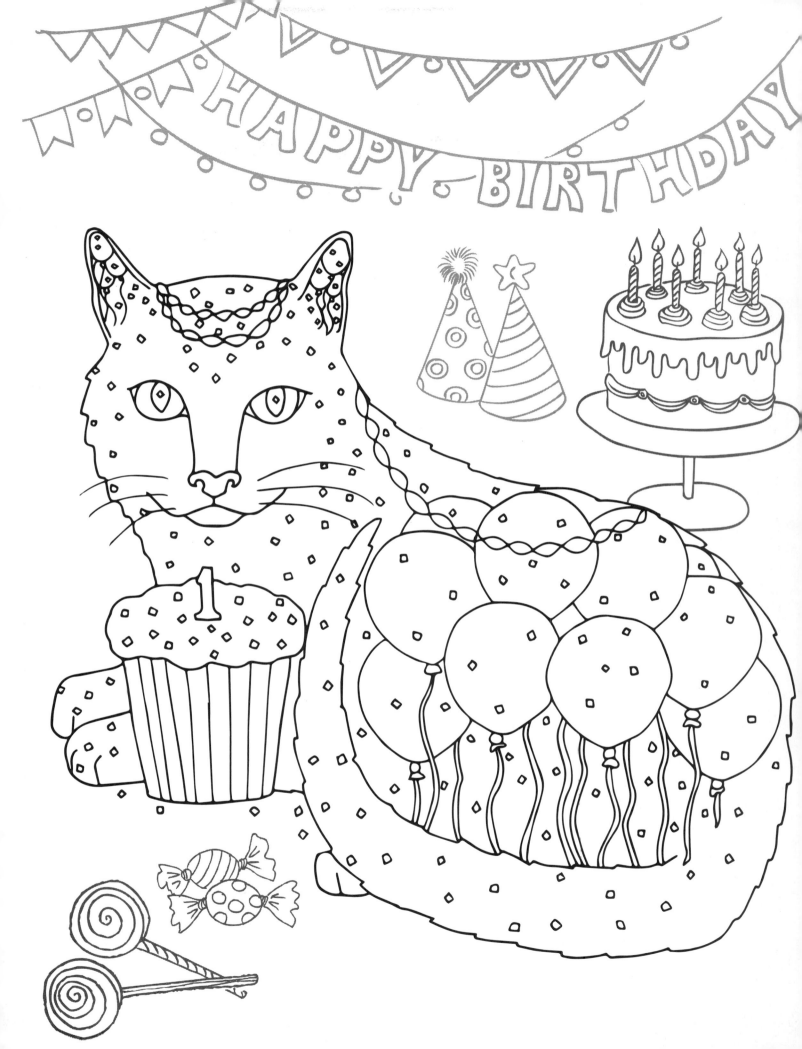

*"The cat is domestic only as far as suits its own ends."*

—Saki

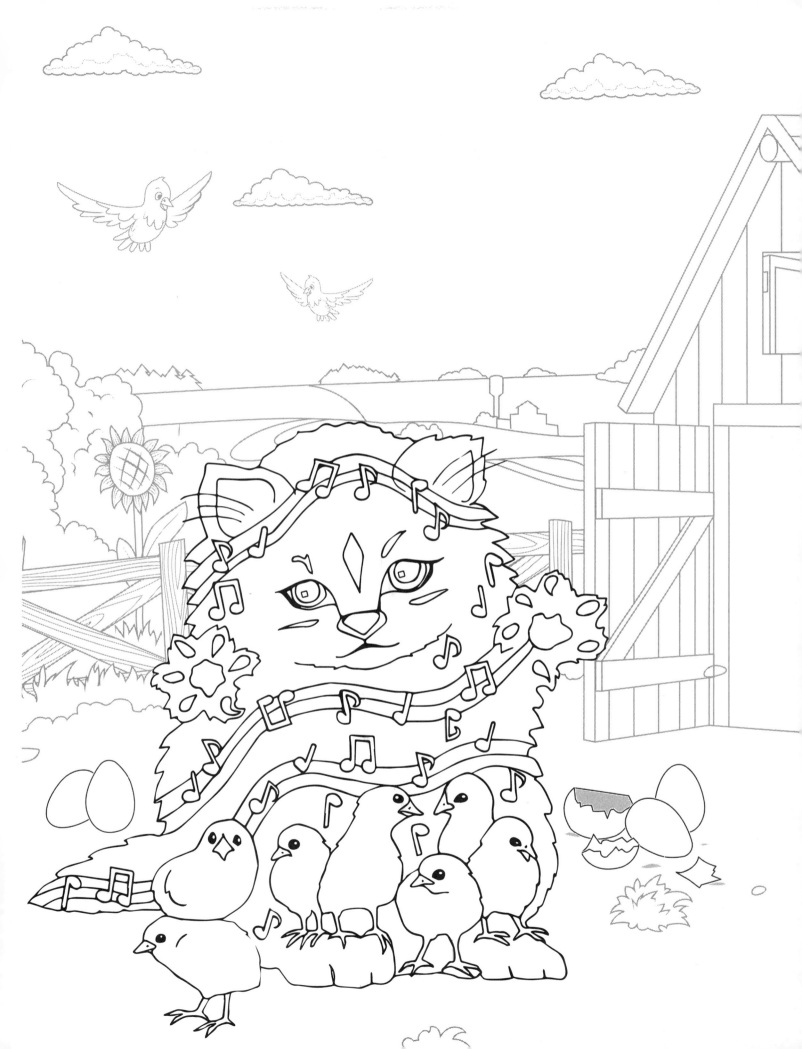

*For many reasons, many people cannot be around cats. What do you think they are missing out on? How can you share your happy experiences with those who do not have pets in their lives?*

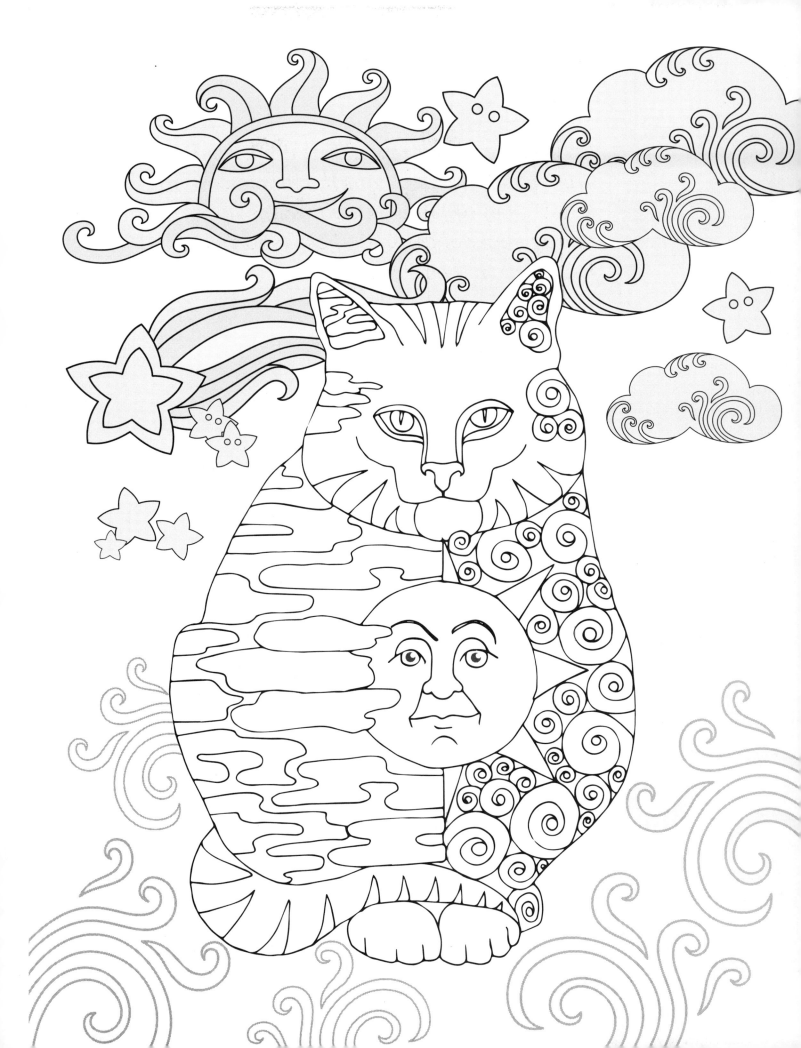

*"I believe cats to be spirits come to earth. A cat, I am sure, could walk on a cloud without coming through."*

–Jules Verne

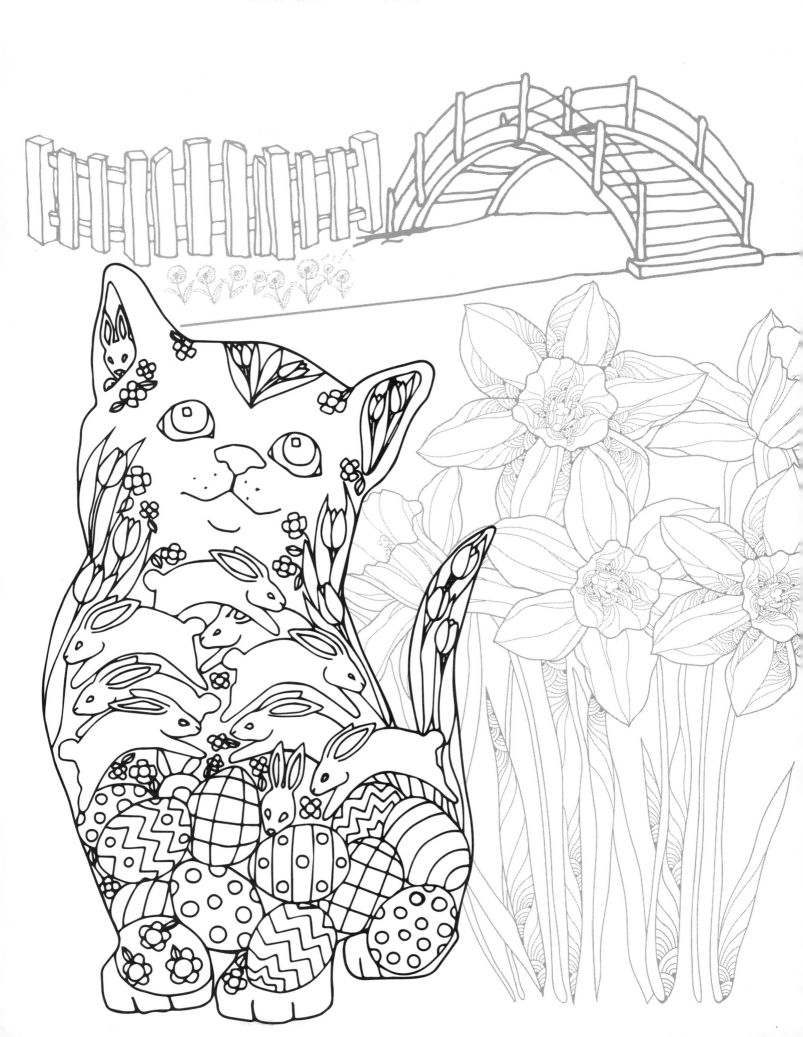

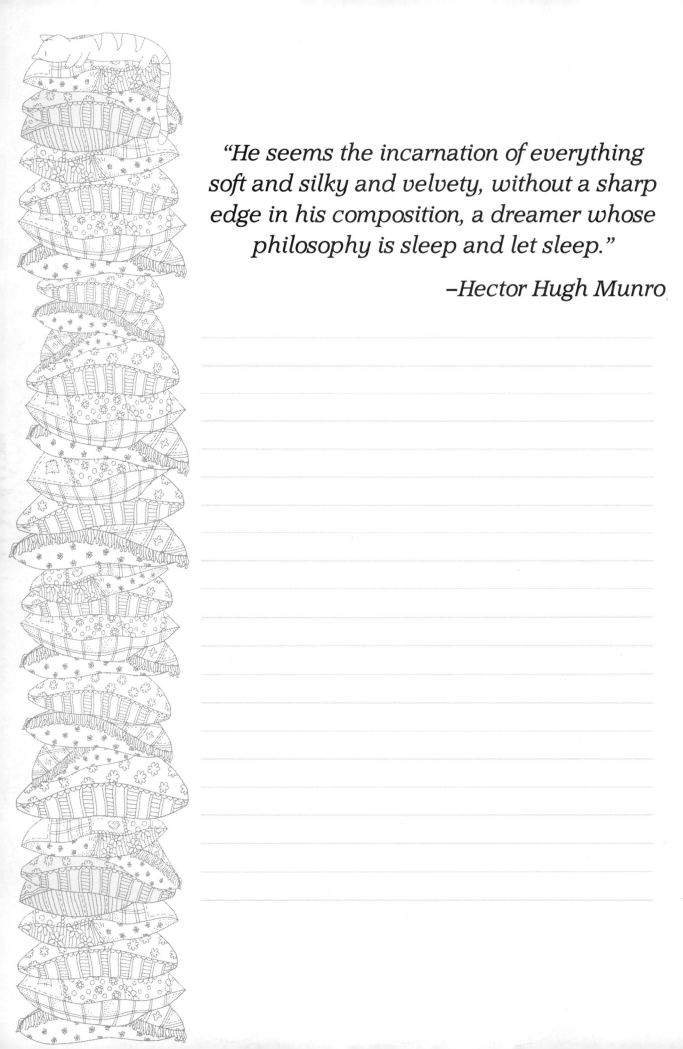

*"He seems the incarnation of everything soft and silky and velvety, without a sharp edge in his composition, a dreamer whose philosophy is sleep and let sleep."*

–Hector Hugh Munro

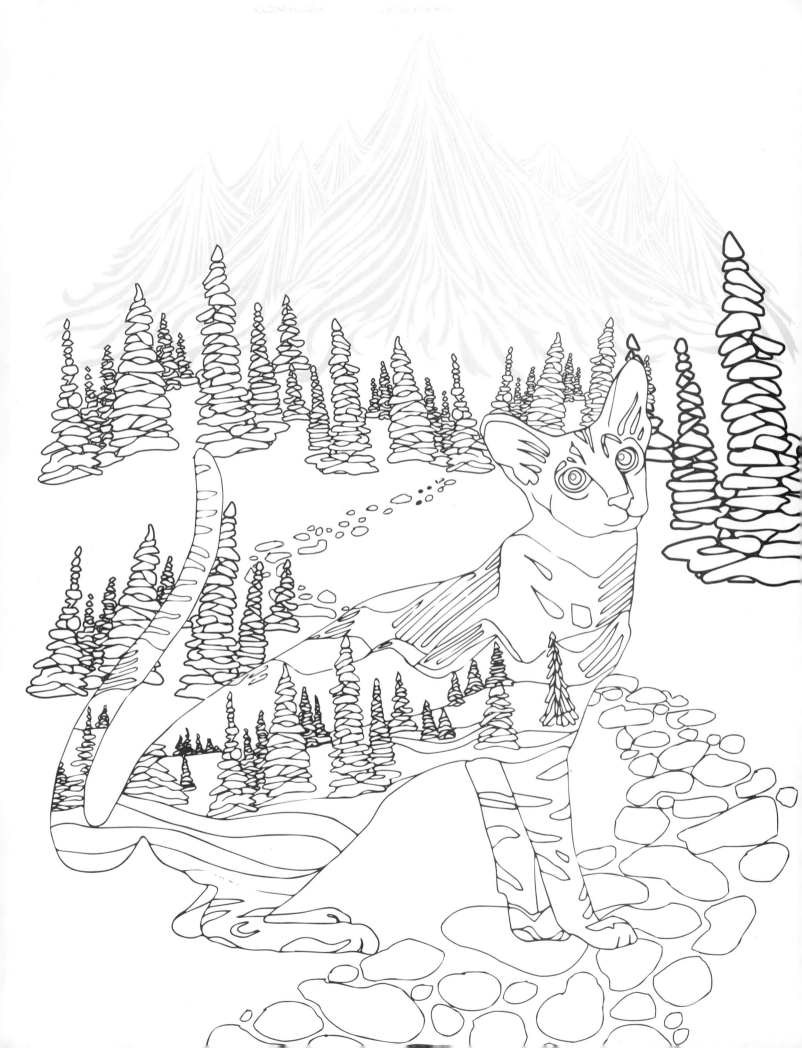

*"There is no more intrepid explorer
than a kitten."*

—Jules Champfleury

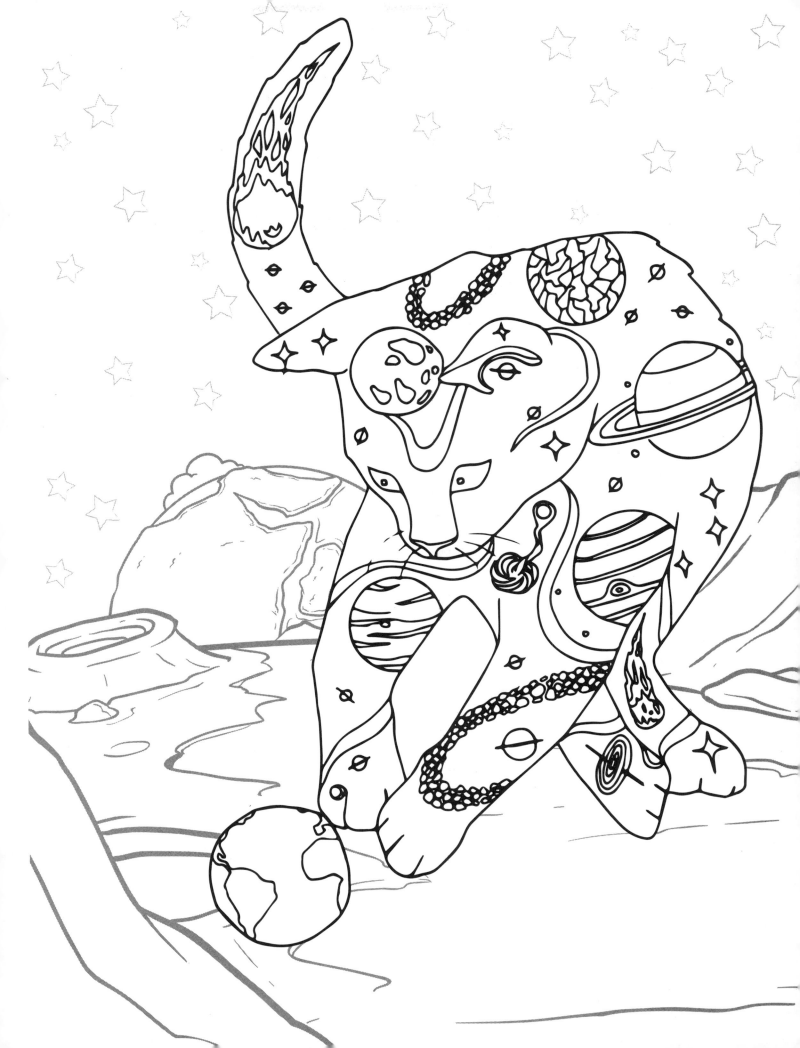

*"I wish I could write as mysterious as a cat."*

–Edgar Allan Poe

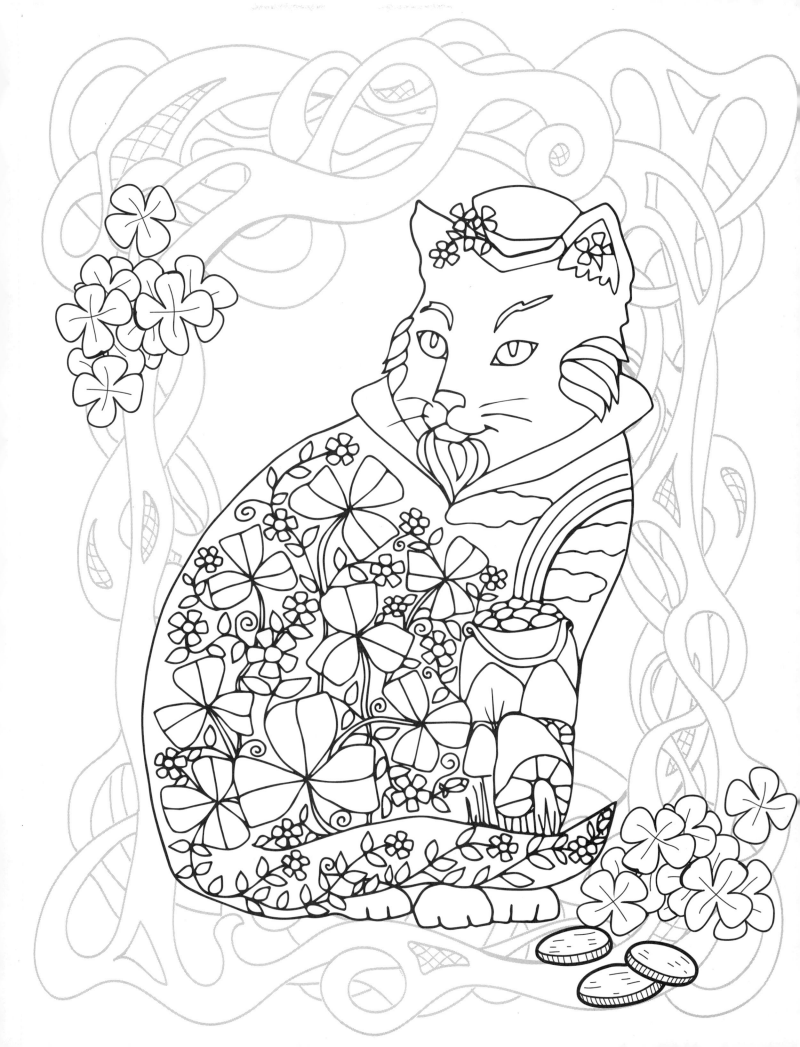

*"You will always be lucky if you know how to make friends with strange cats."*

*–Proverb*

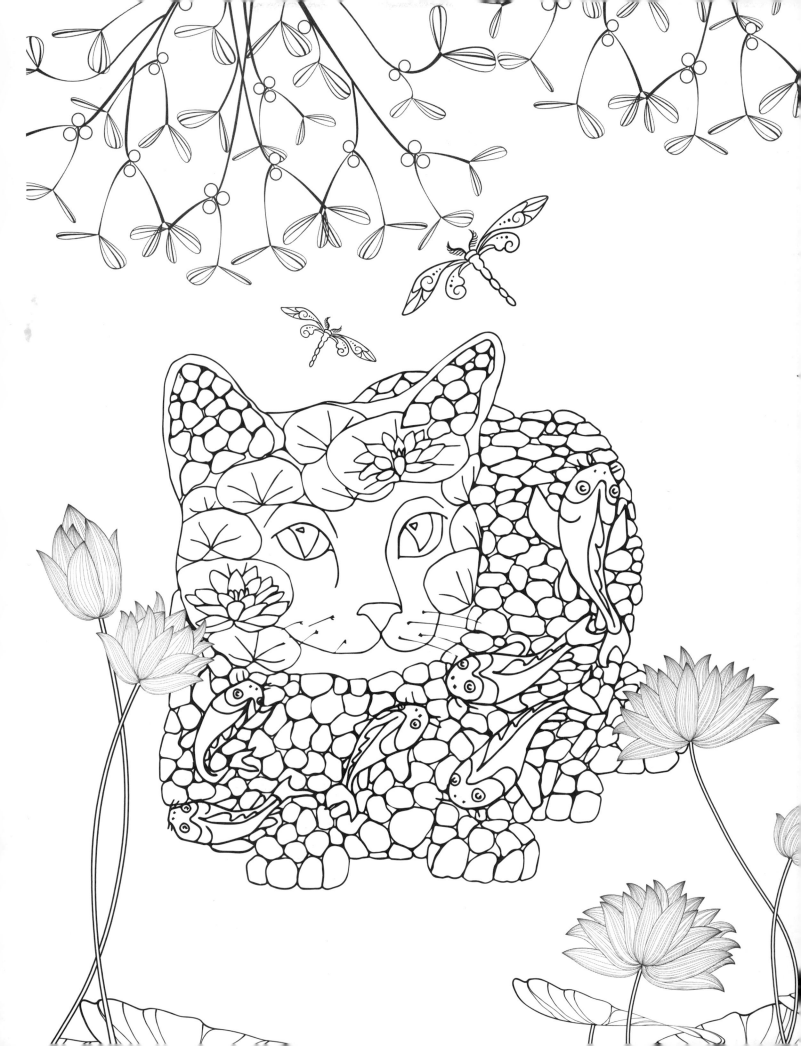

*Do you like to color by yourself or with friends? What is better about coloring in the company of others? What is better about coloring alone? Knowing what makes each experience special can help you take better care of yourself.*

_____

_____

_____

_____

_____

_____

_____

_____

_____

_____

_____

_____

_____

_____

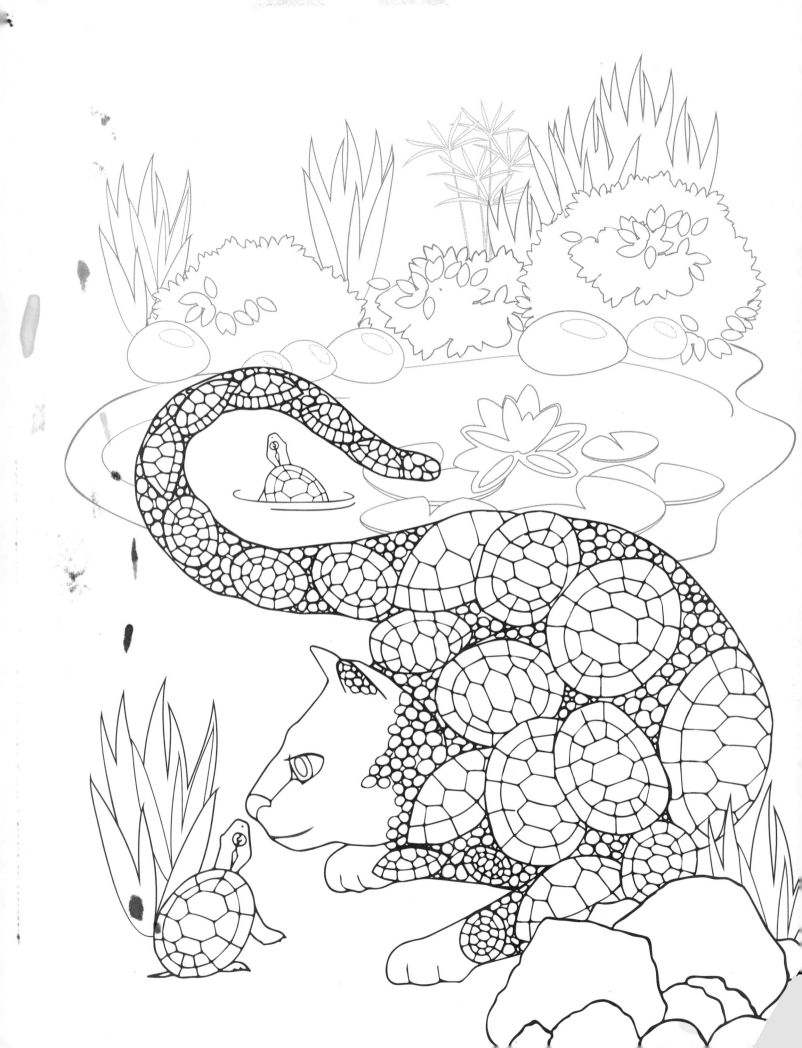

*"The ideal of calm exists in a sitting cat."*

*–Jules Reynard*

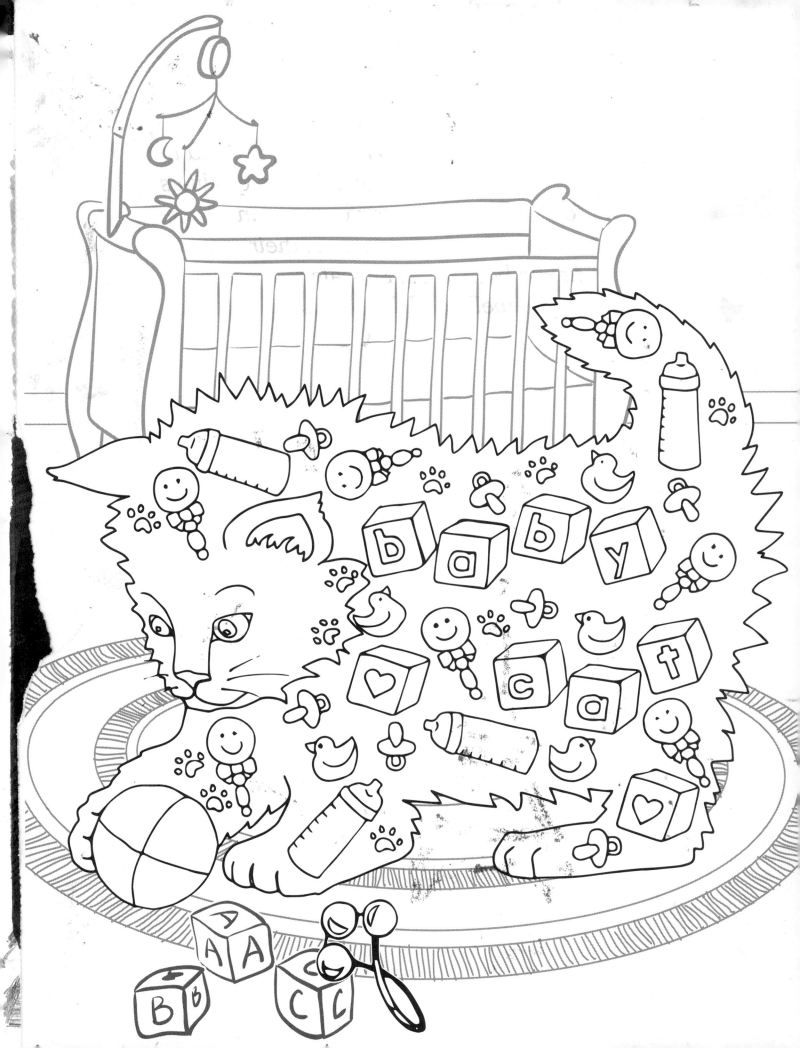

*"Dogs come when they are called. Cats take a message and get back to you later."*

−*Mary Bly*

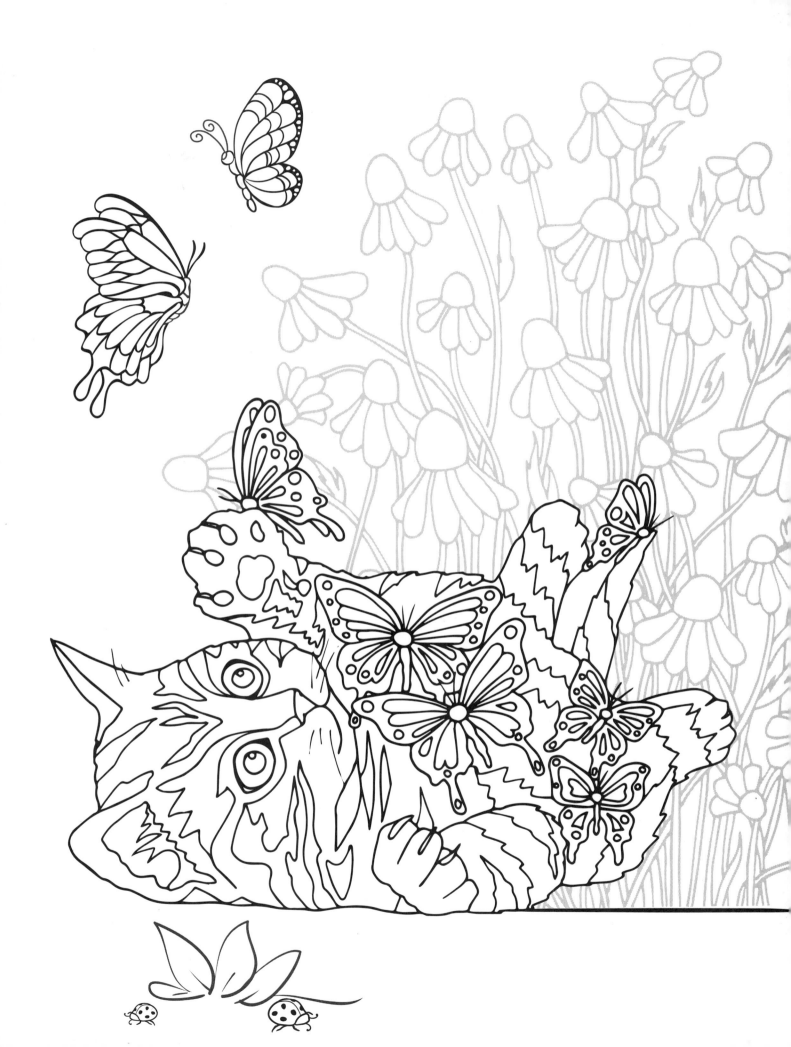

*"The cat is the animal to whom the Creator gave the biggest eye, the softest fur, the most supremely delicate nostrils, a mobile ear, an unrivaled paw and a curved claw borrowed from the rose-tree."*

–Sidonie Gabrielle Colette

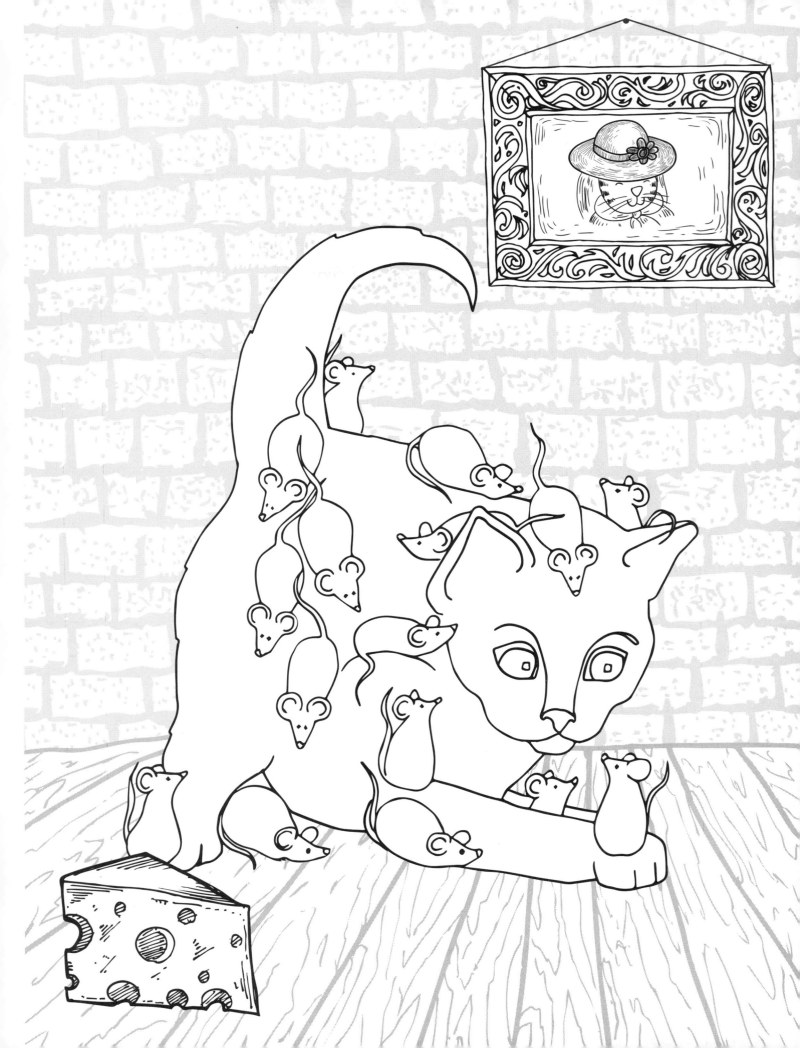

*"I have studied many philosophers and many cats. The wisdom of cats is infinitely superior."*

–Hippolyte Taine

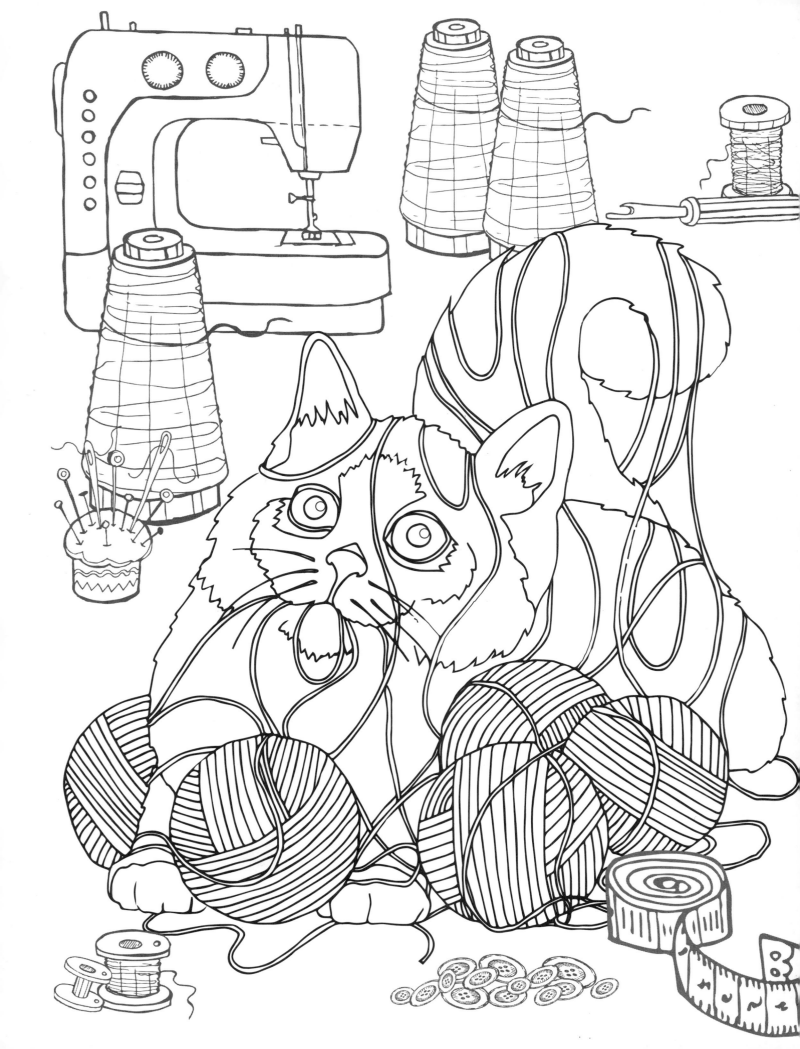

*"Each new kitten becomes its own cat, and none is repeated. I am four cats old, measuring out my life in friends that have succeeded but not replaced one another."*

–Irving Townsend

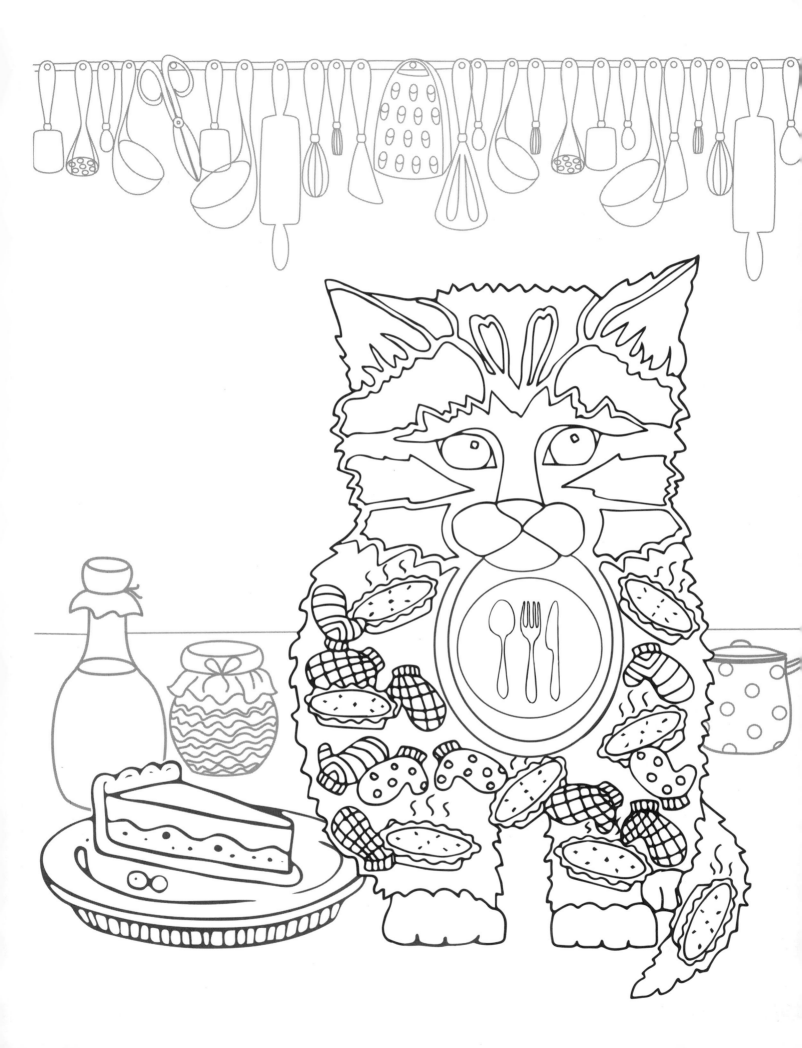

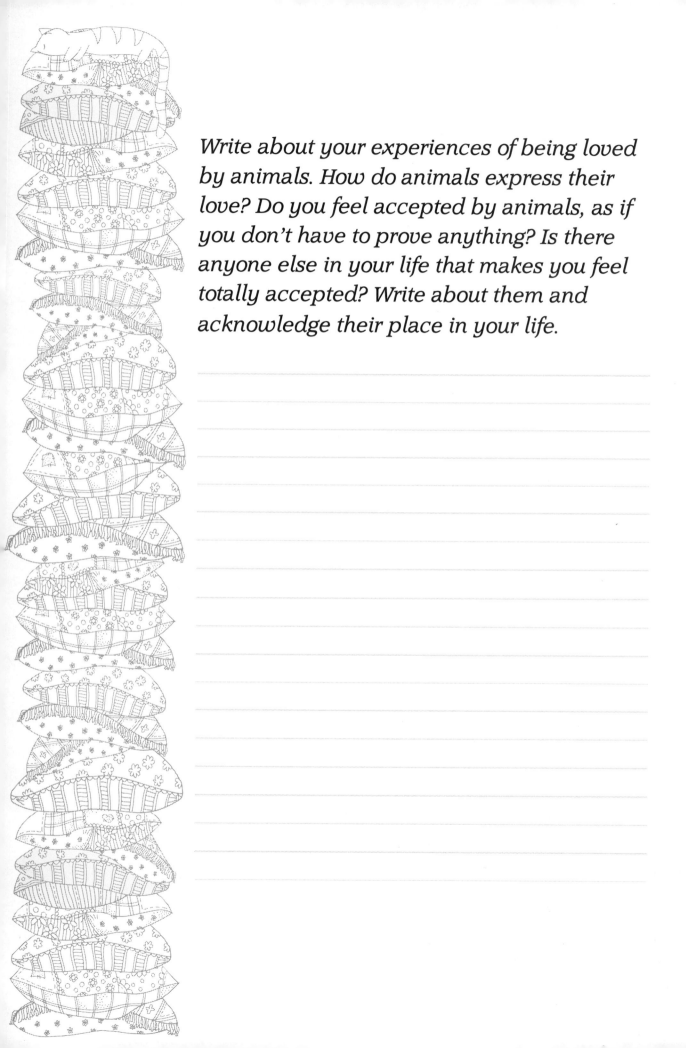

Write about your experiences of being loved by animals. How do animals express their love? Do you feel accepted by animals, as if you don't have to prove anything? Is there anyone else in your life that makes you feel totally accepted? Write about them and acknowledge their place in your life.

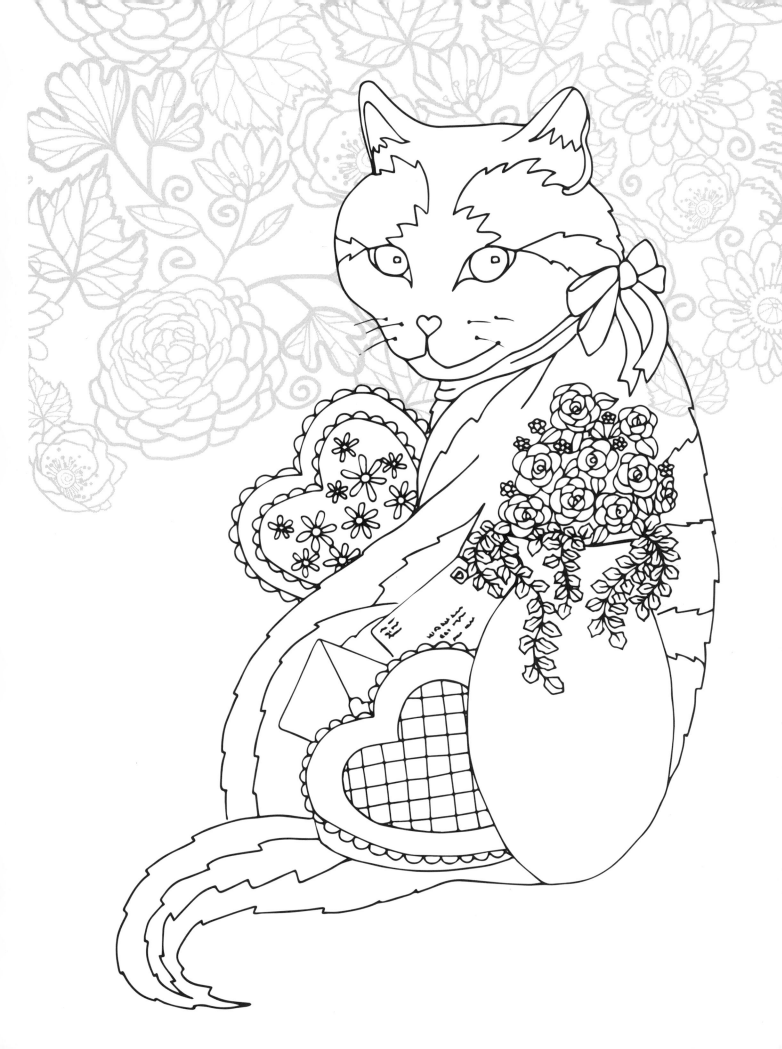

*"Wherever a cat sits,*
*there shall happiness be found."*

*–Stanley Spencer*

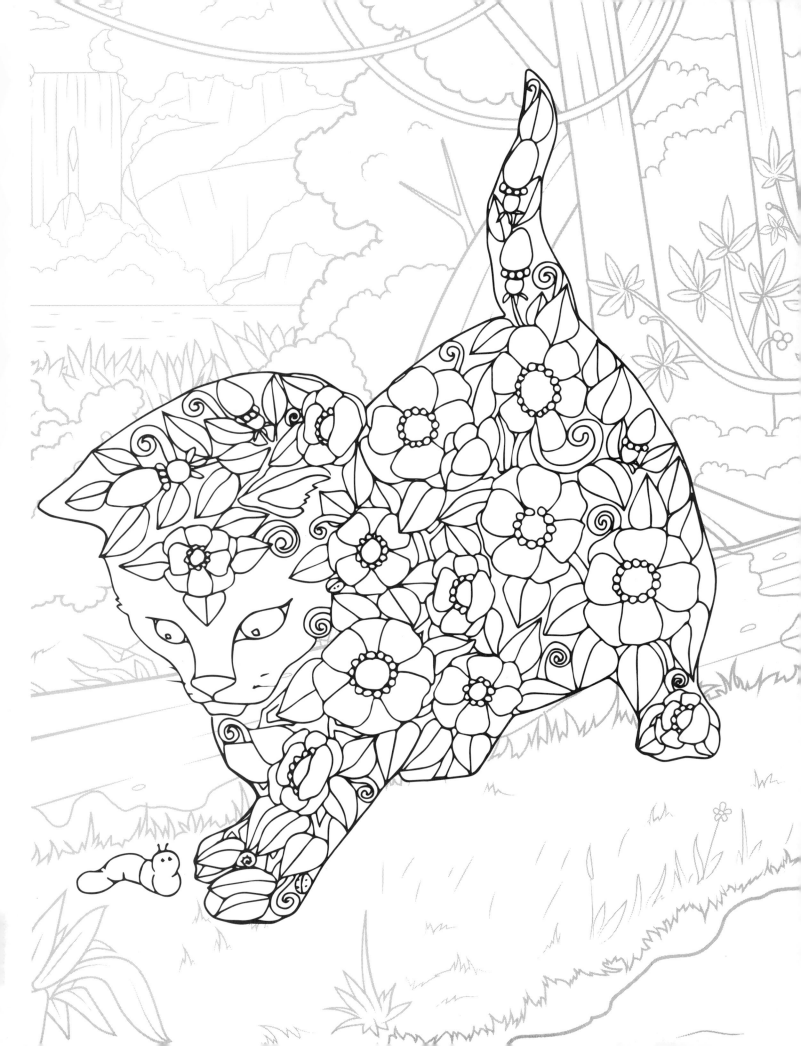

*"A cat is a lion in a jungle of small bushes."*

*–Indian proverb*

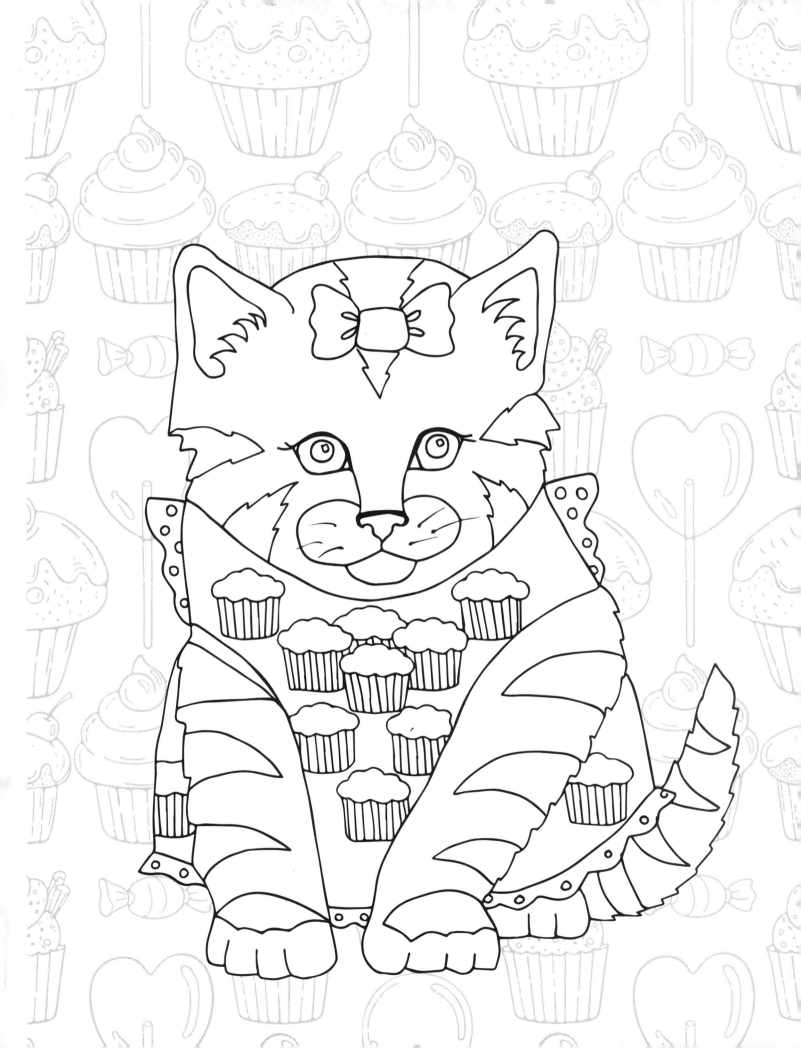

*"Who would believe such pleasure
from a wee ball o' fur?"*

*—Irish saying*

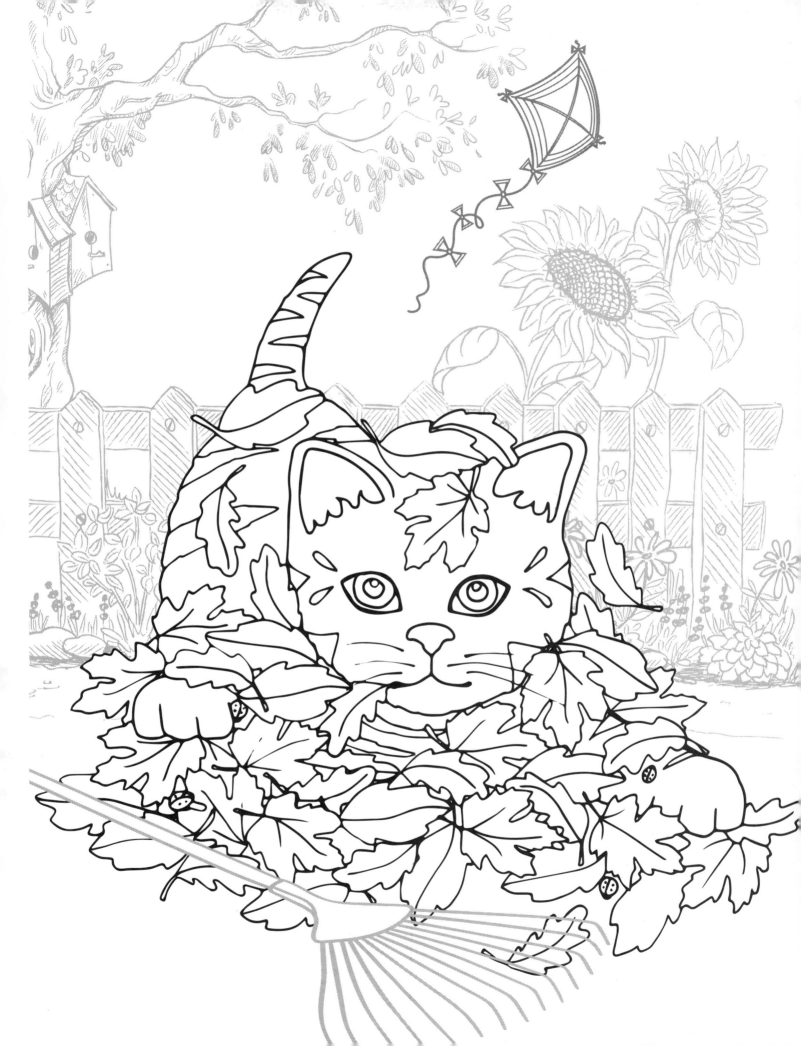

*"The dog may be wonderful prose,*
*but only the cat is poetry."*

*−French proverb*

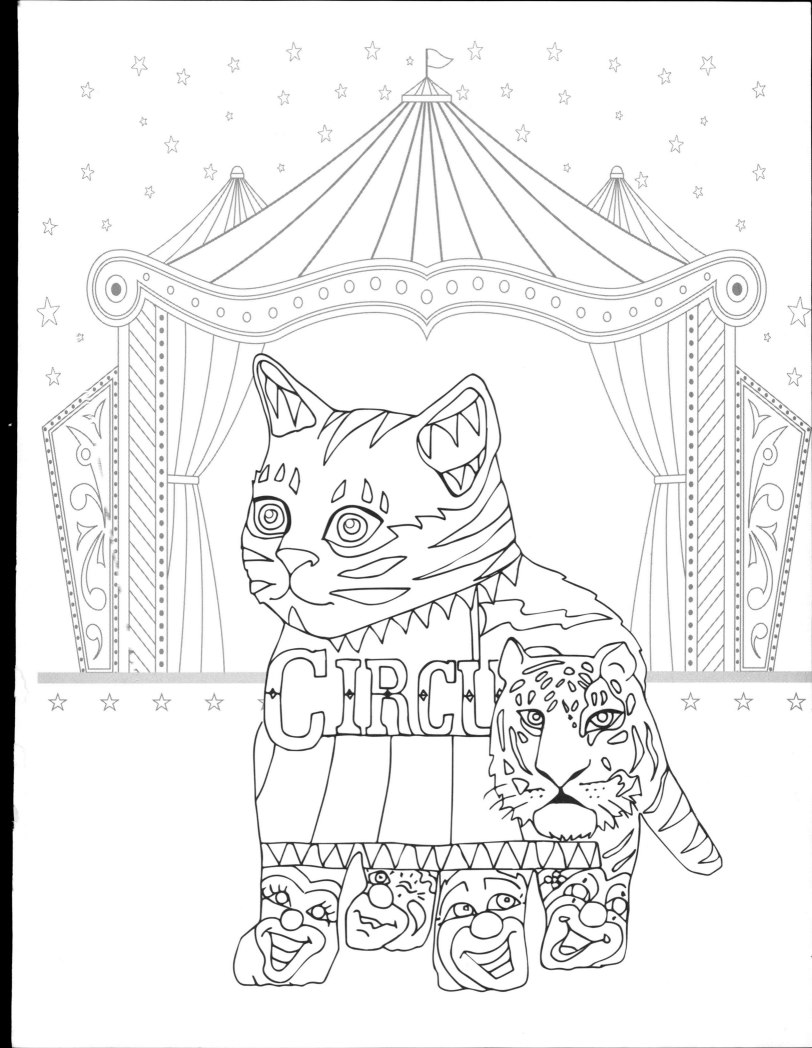

*How do cats make you laugh?*

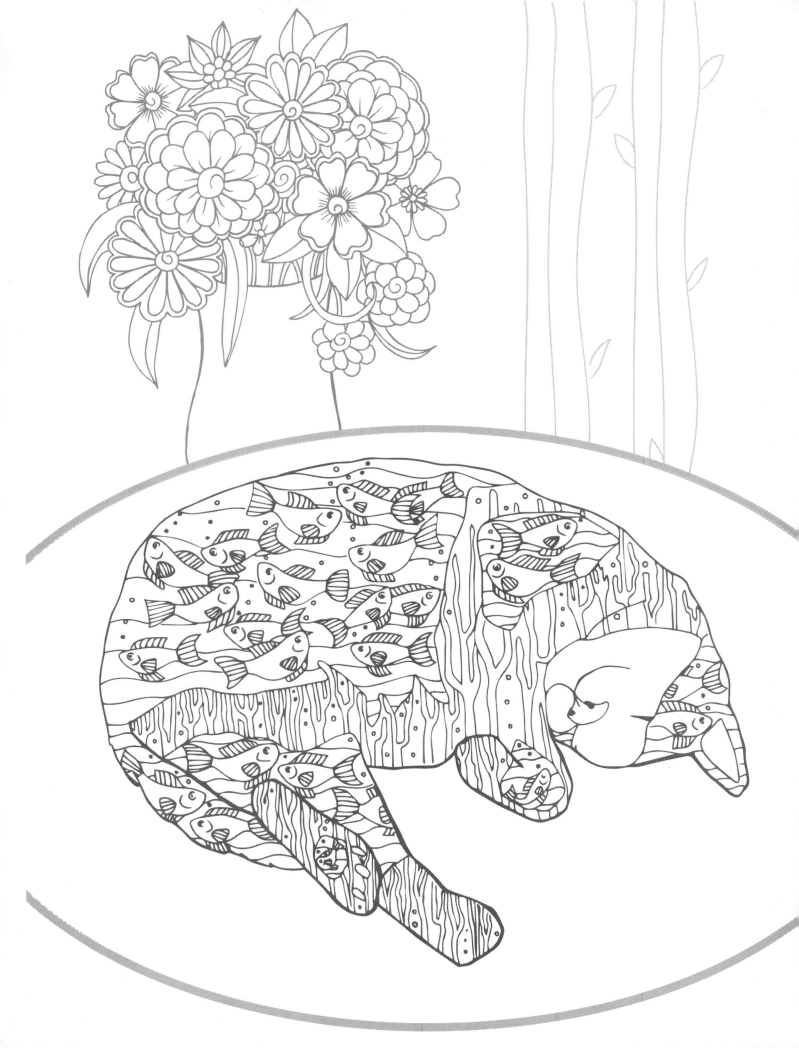

*"When she walked . . . she stretched out long and thin like a little tiger, and held her head high to look over the grass as if she were treading the jungle."*

*–Sarah Orne Jewett*

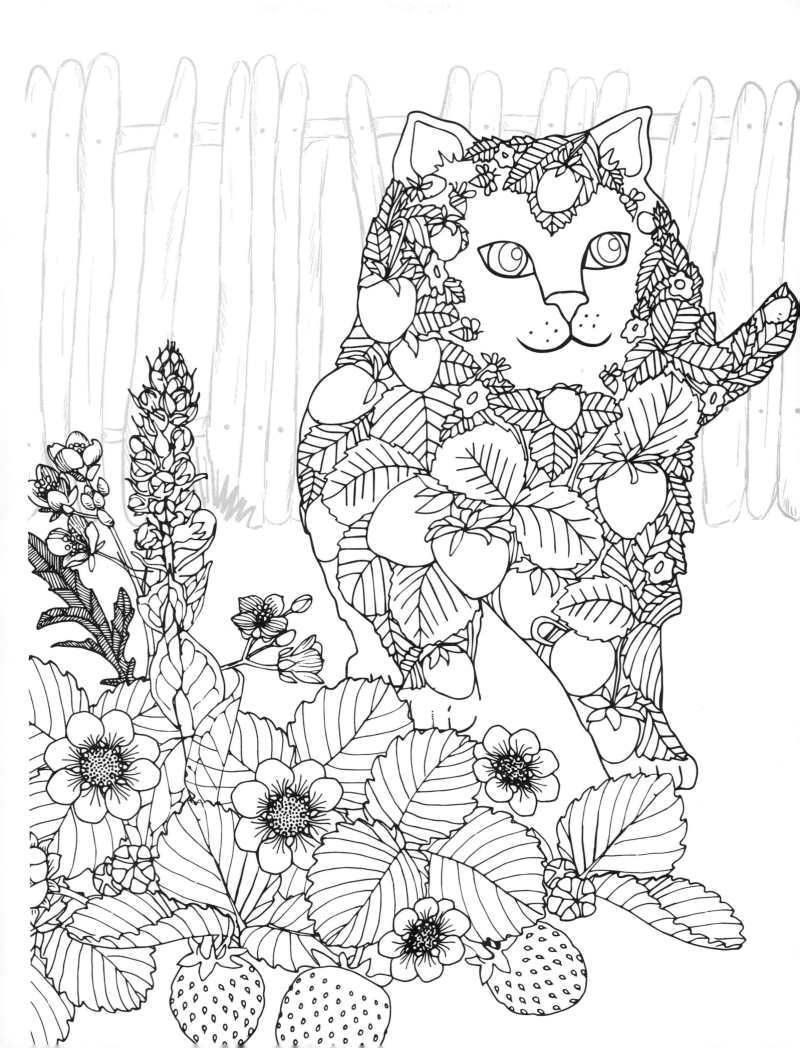

*"The cat is above all things, a dramatist."*

–Margaret Benson

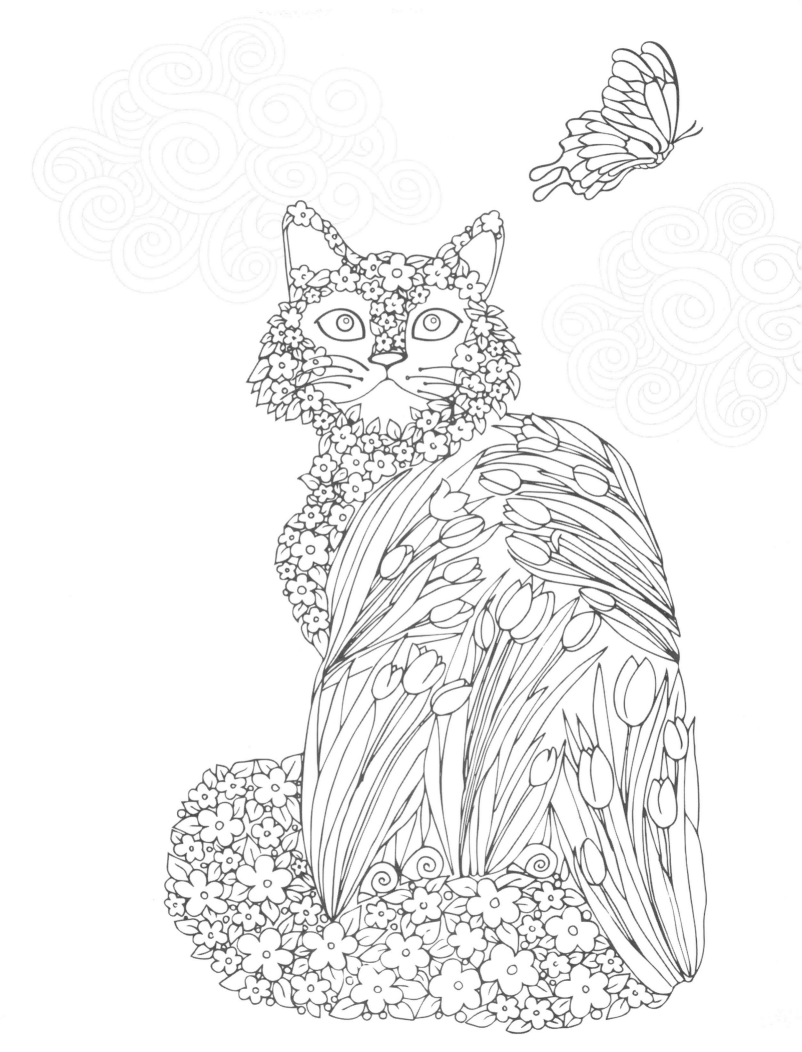

*"If man could be crossed with the cat it would improve man, but it would deteriorate the cat."*

–Mark Twain

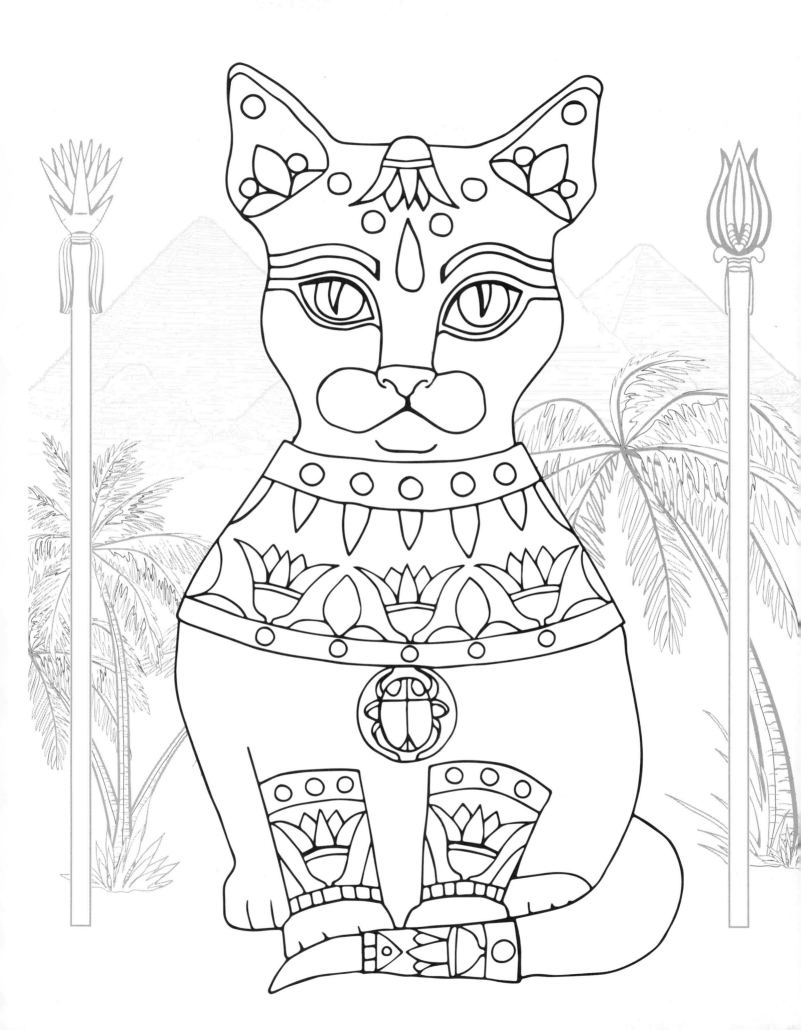

*"Like those great sphinxes lounging through eternity in noble attitudes upon the desert sand, they gaze incuriously at nothing, calm and wise."*

*–Charles Baudelaire*

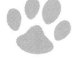
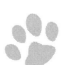

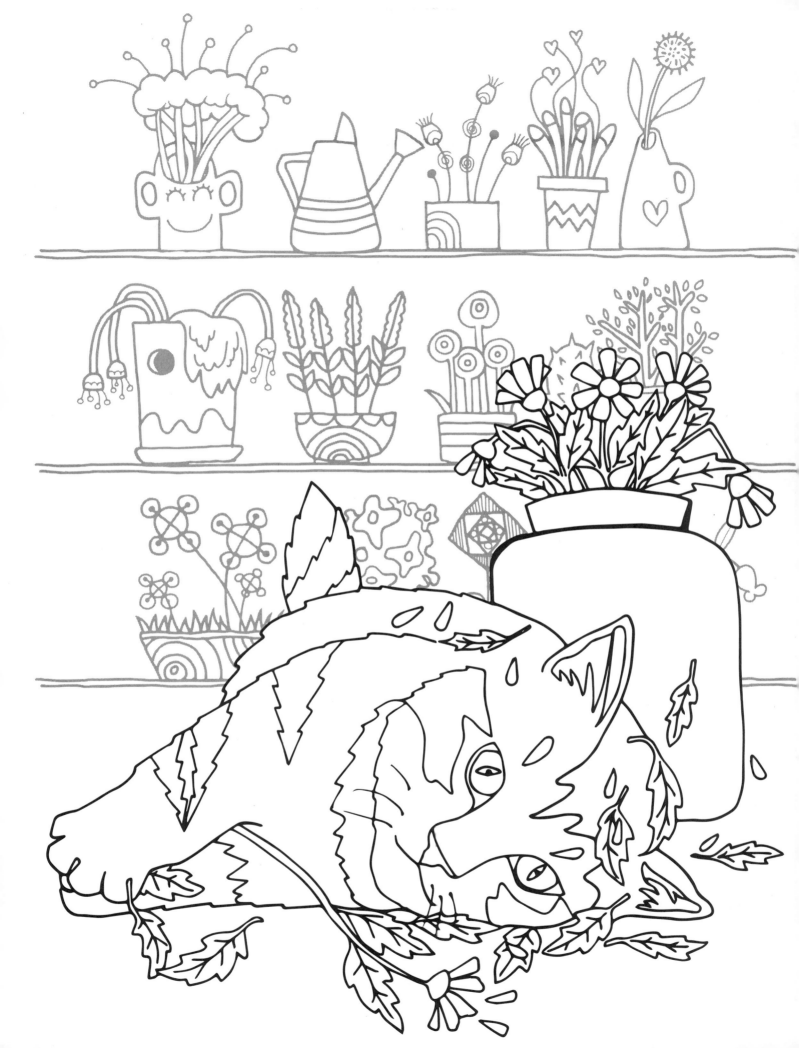

*"Dogs have owners, cats have staff."*

–Anonymous

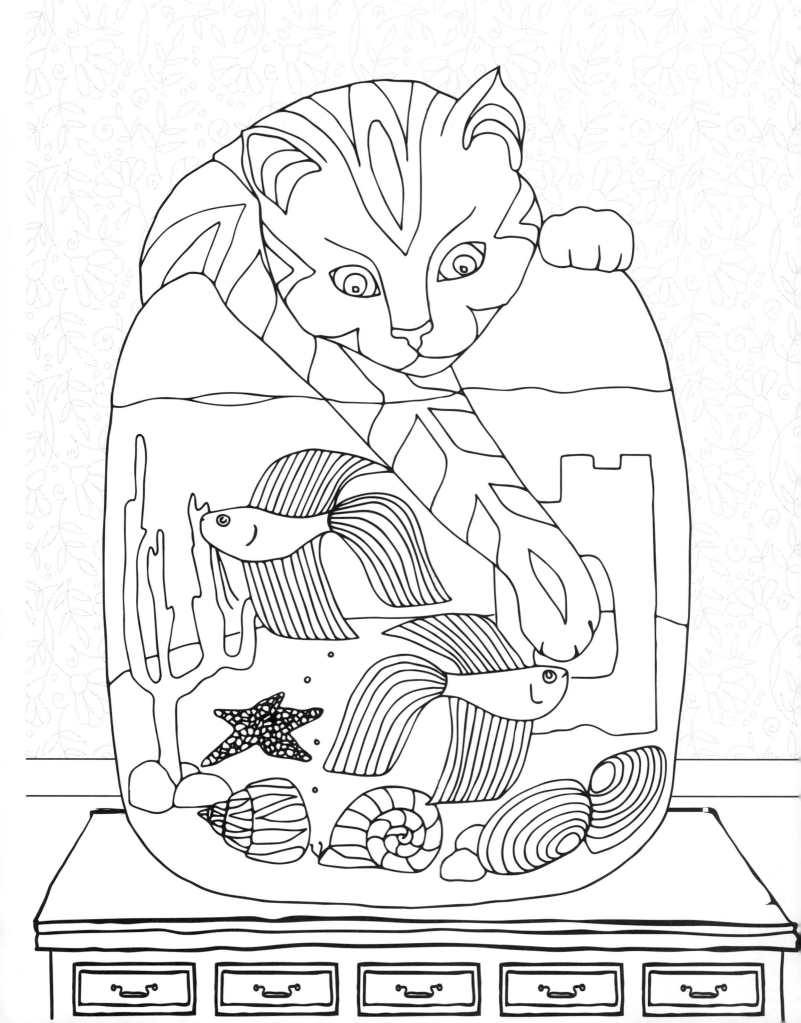

*"The smallest feline is a masterpiece."*

–Leonardo da Vinci

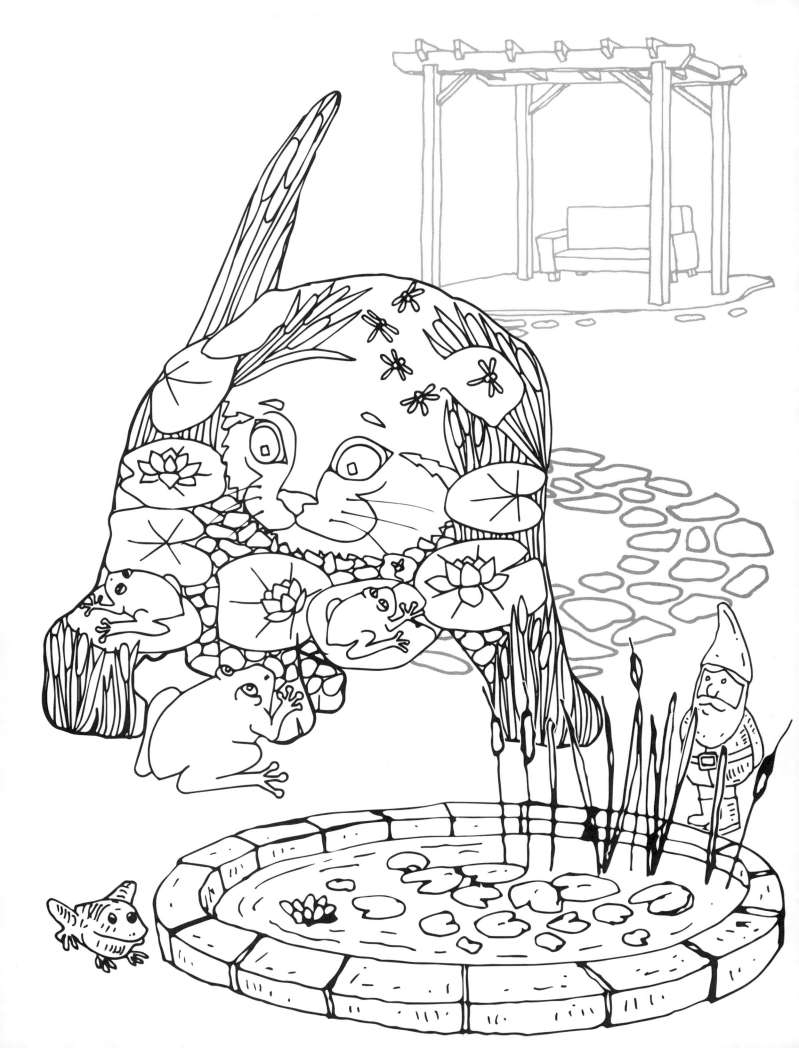

*"In the beginning, God created man, but seeing him so feeble, He gave him the cat."*

–Warren Eckstein

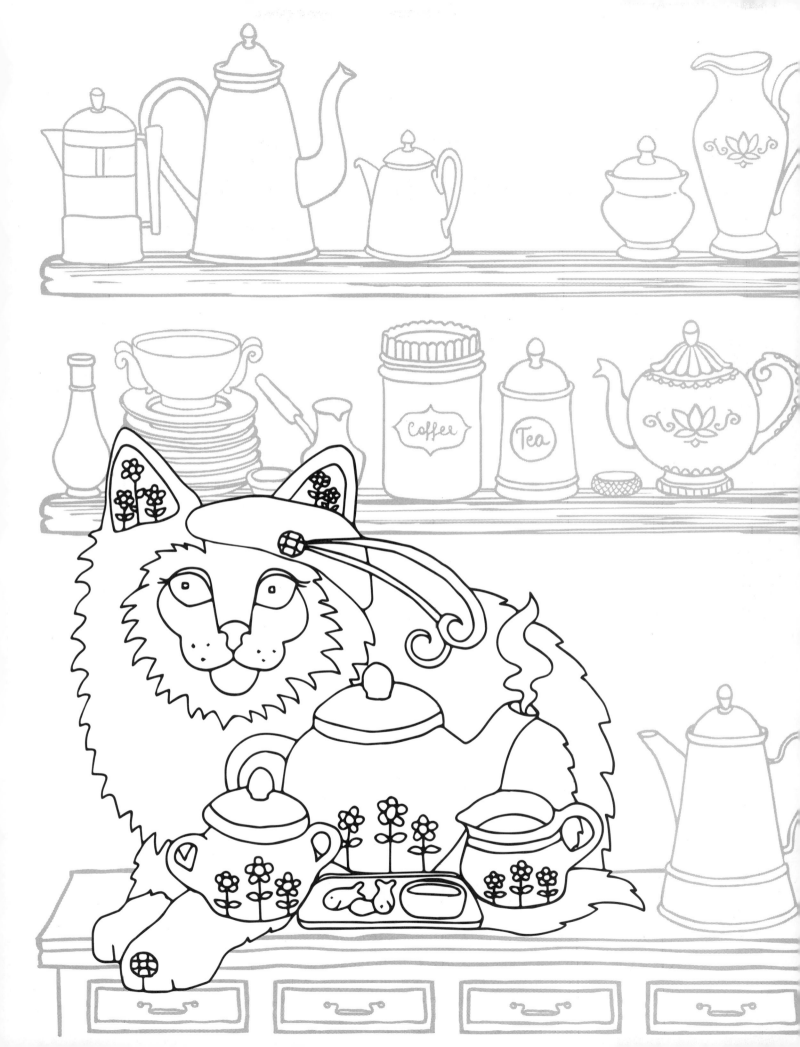

*"Cats are a mysterious kind of folk.*
*There is more passing in their minds*
*than we are aware of."*

*–Walter Scott*

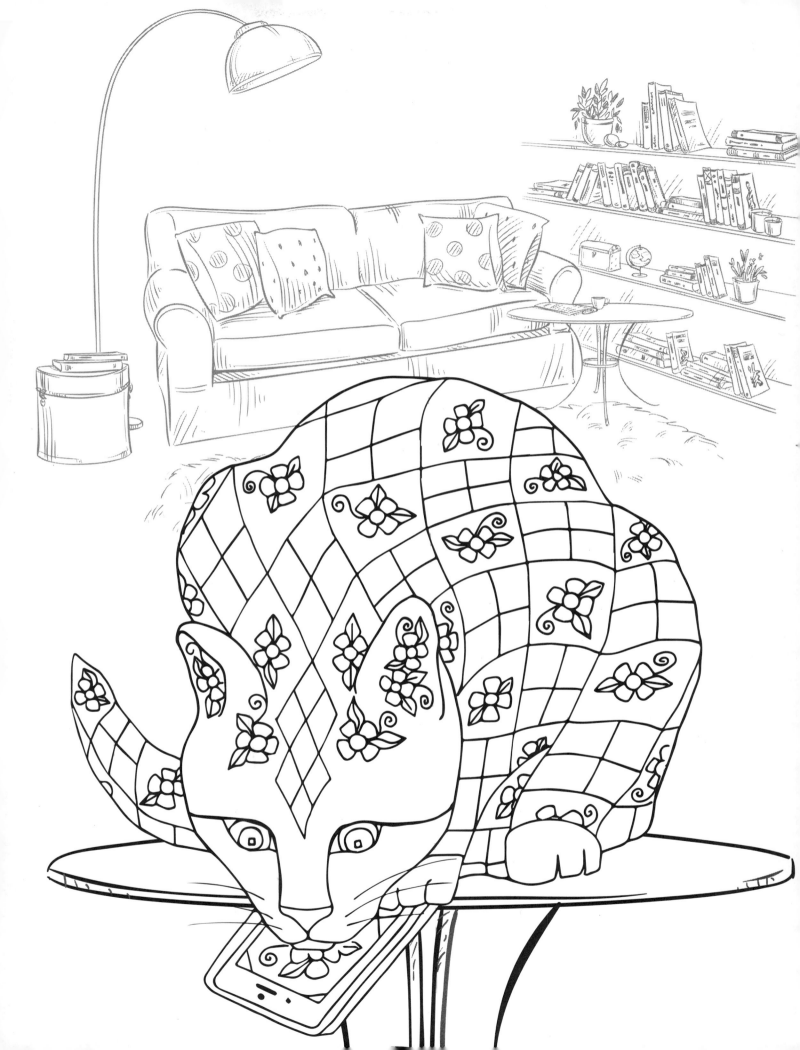

*"There are no ordinary cats."*

–Sidonie Gabrielle Colette

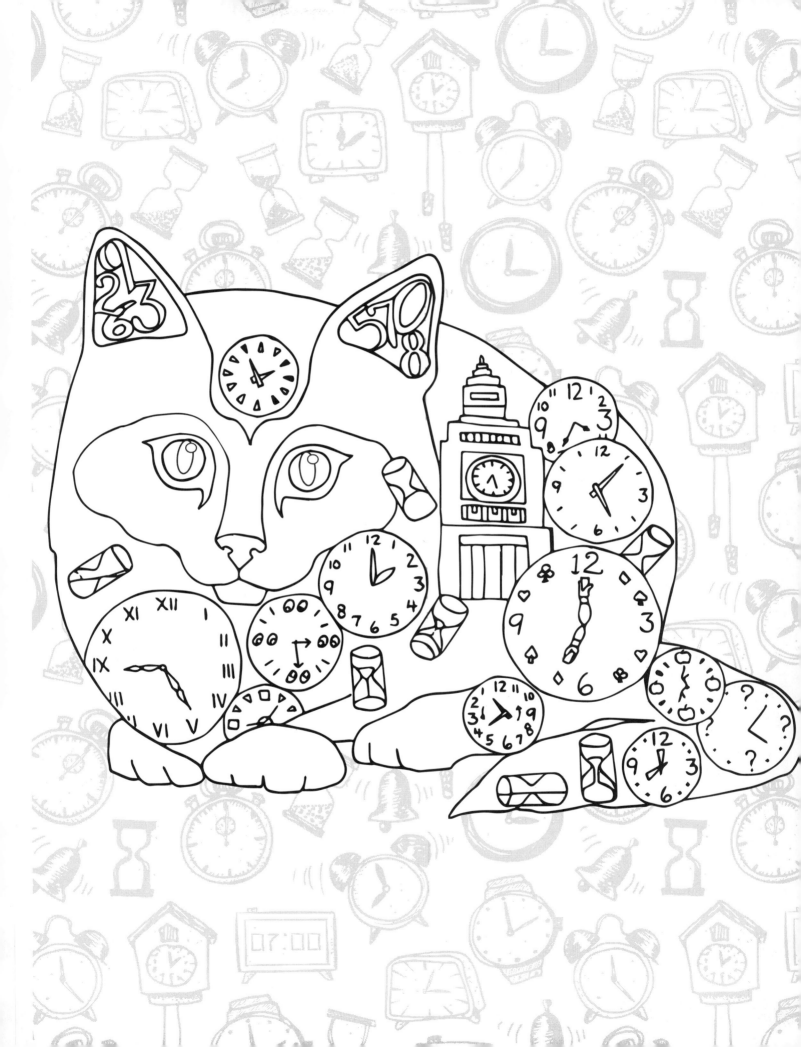

*"Time spent with a cat is never wasted."*

*–Sidonie Gabrielle Colette*

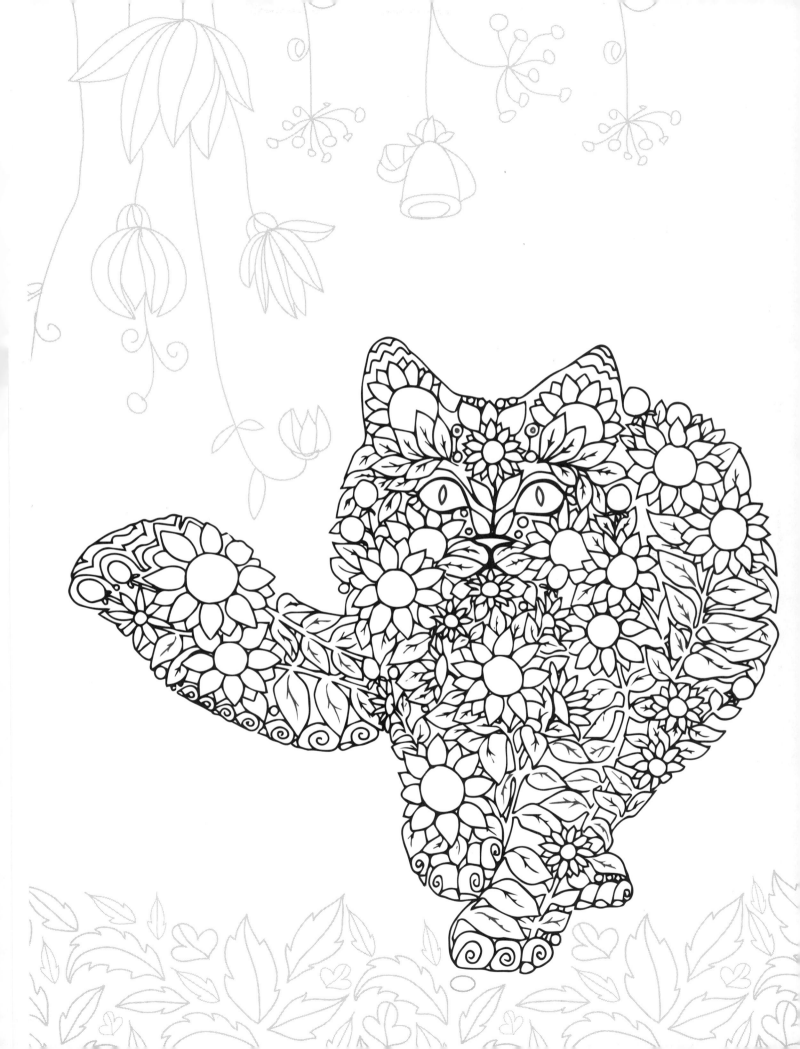

*What do you have in common with this picture? Is it happy or serious? Whimsical or realistic?*

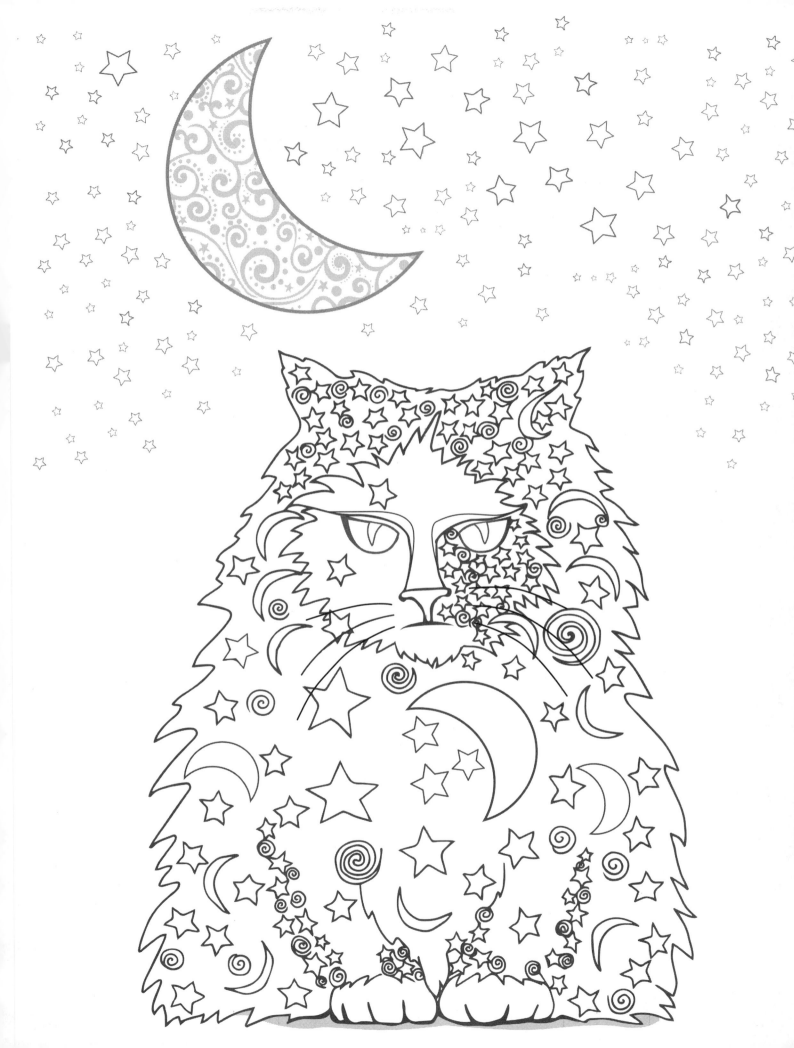

*"They say the test of literary power is whether a man can write an inscription. I say, 'Can he name a kitten?'"*

*–Samuel Butler*

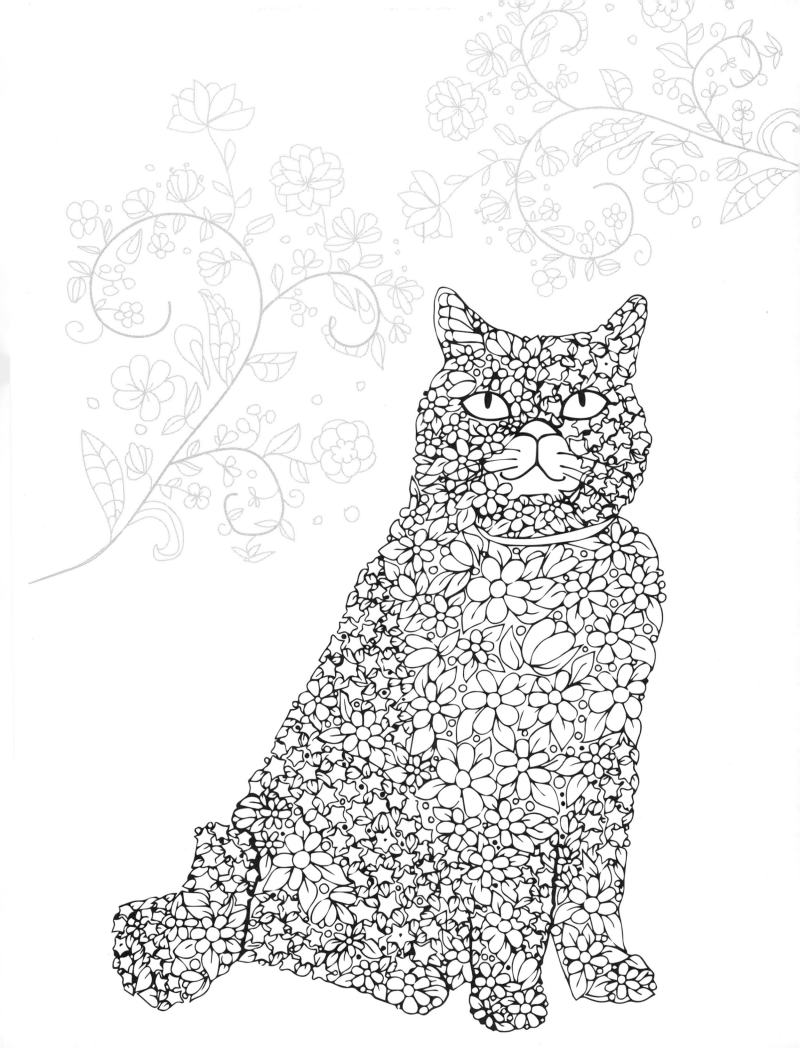

*"The cat dwells within the circle
of her own secret thoughts."*

–Agnes Repplier

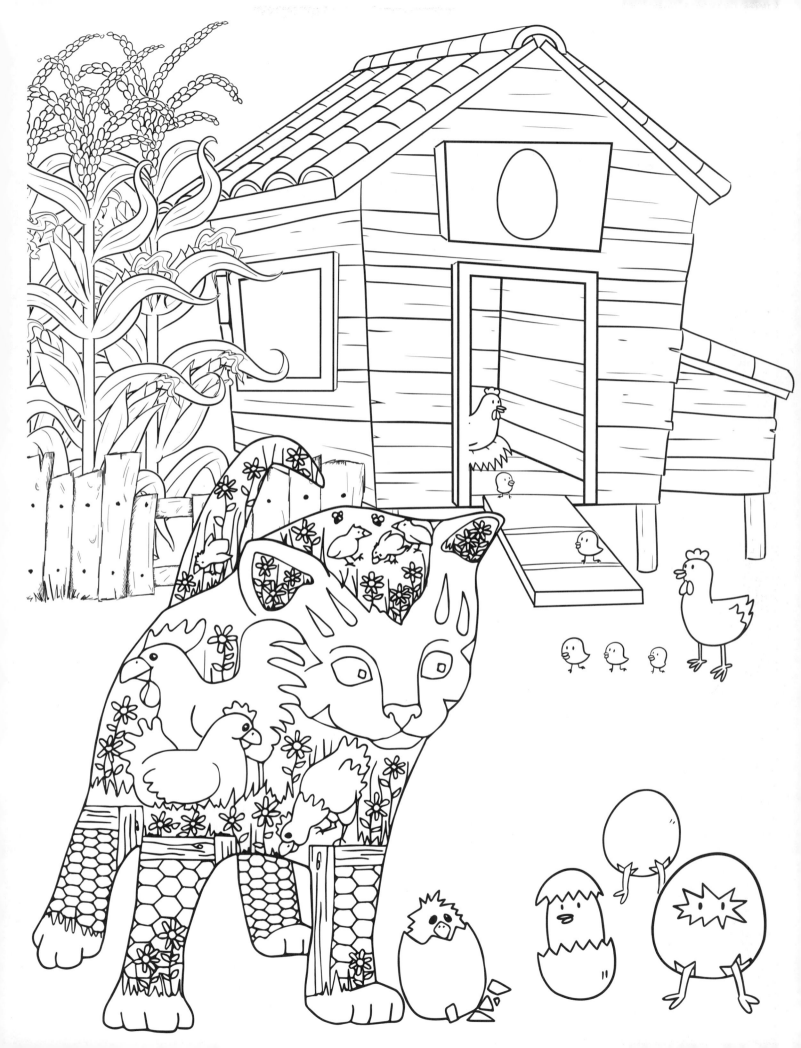

*"There is nothing sweeter than his peace when at rest, for there is nothing brisker than his life when in motion."*

*–Christopher Smart*

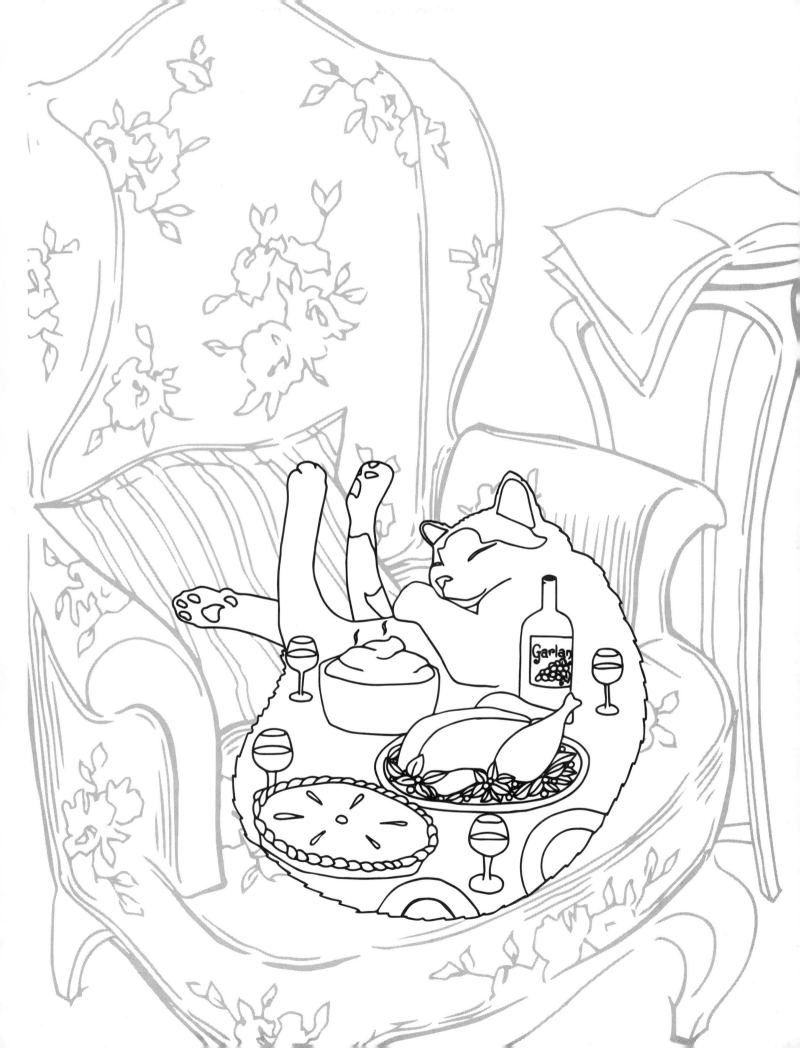

"A kitten is the delight of a household.
All day long, comedy is played by an
incomparable actor."

–Jules Champfleury

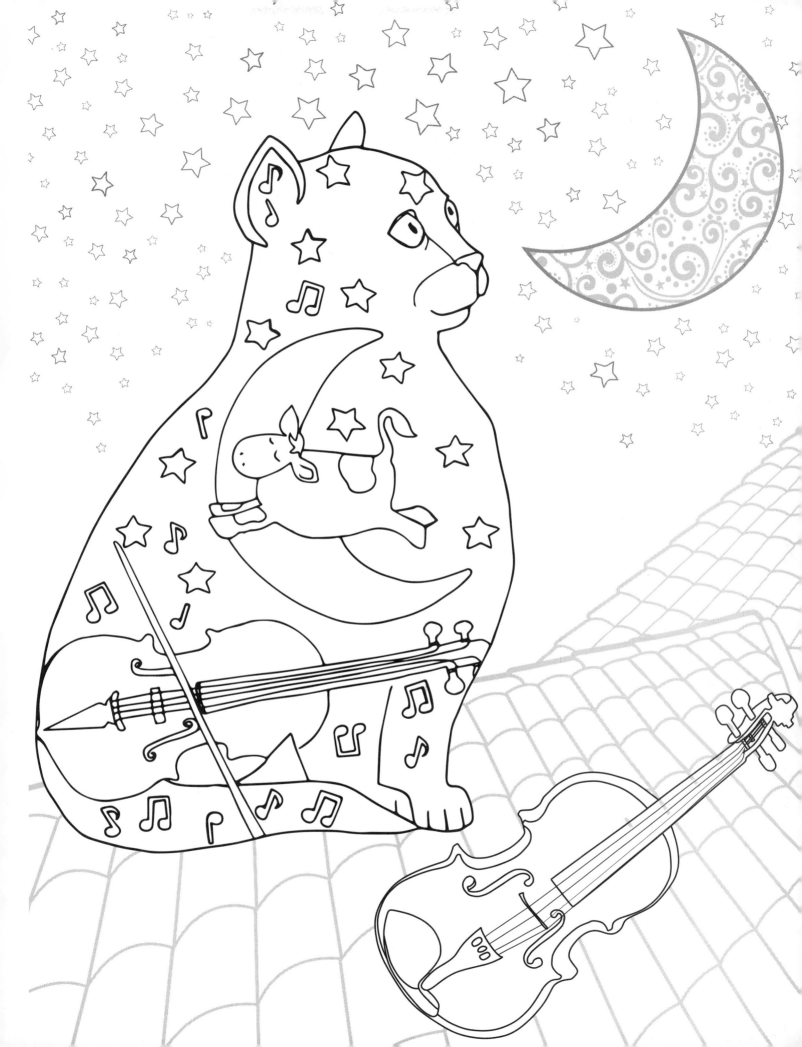

*"The cat is cryptic, and close to strange things which men cannot see."*

–H.P. Lovecraft

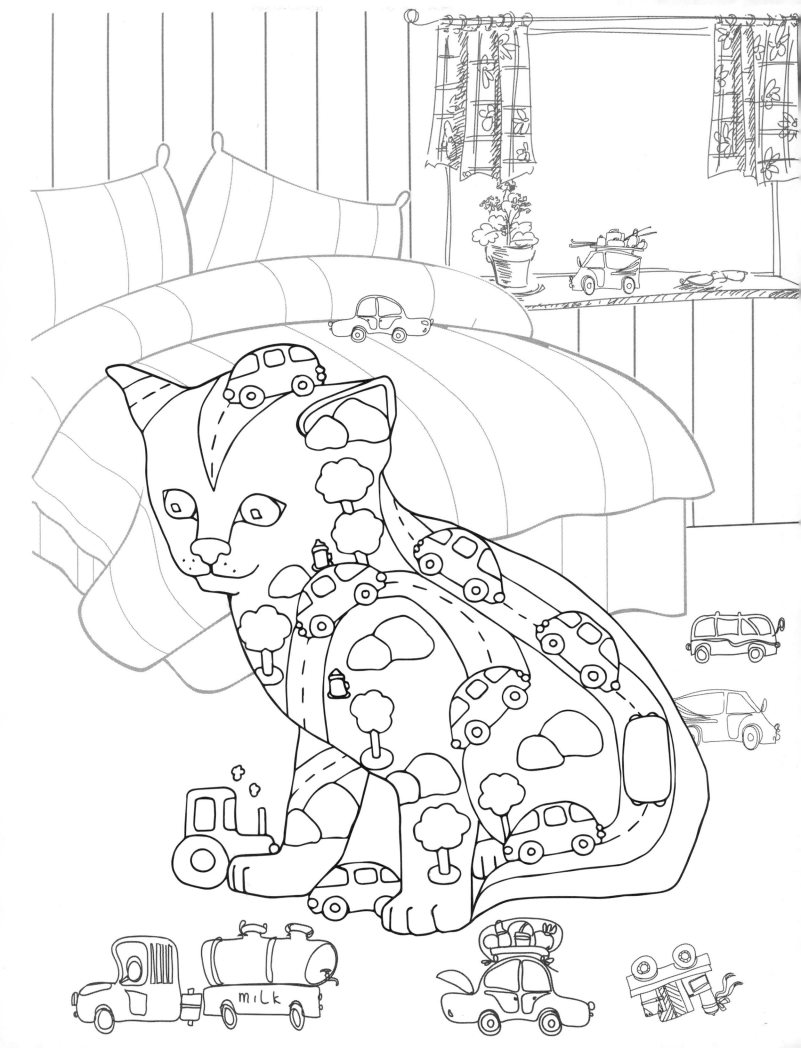

"When there was room on the ledge outside of the pots and boxes for a cat, the cat was there–in sunny weather–stretched at full length, asleep and blissful, with her furry belly to the sun and a paw curved over her nose."

–Mark Twain

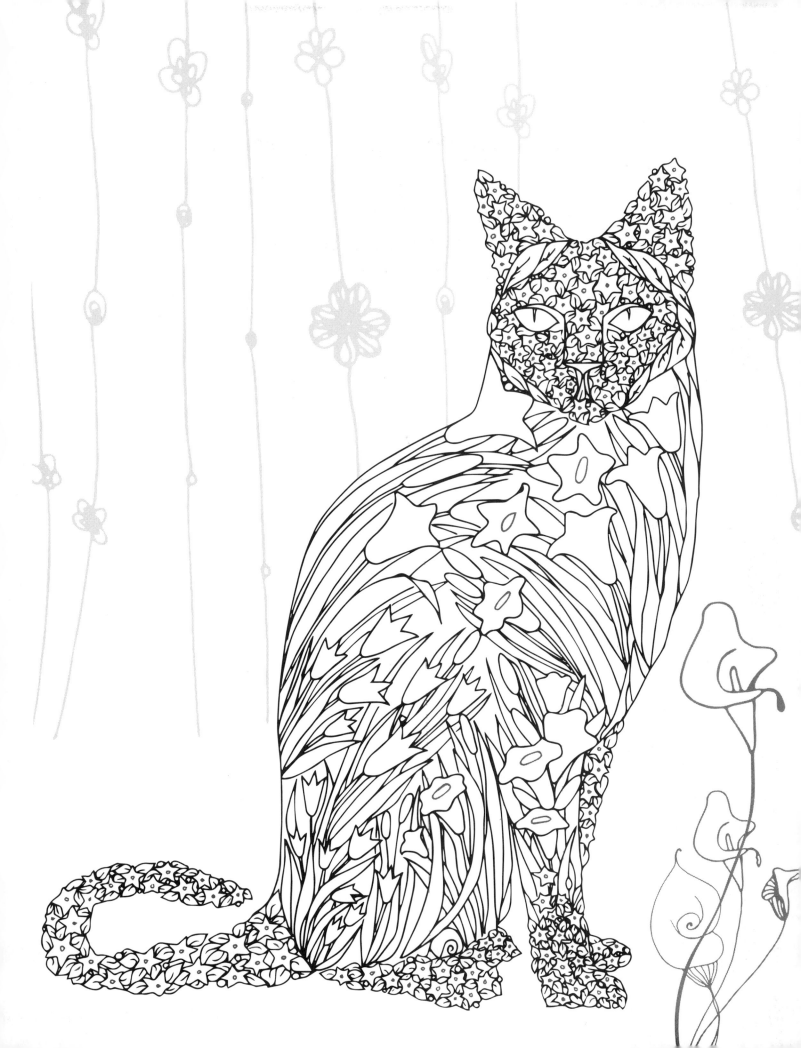

*"Cats are connoisseurs of comfort."*

–James Herriot

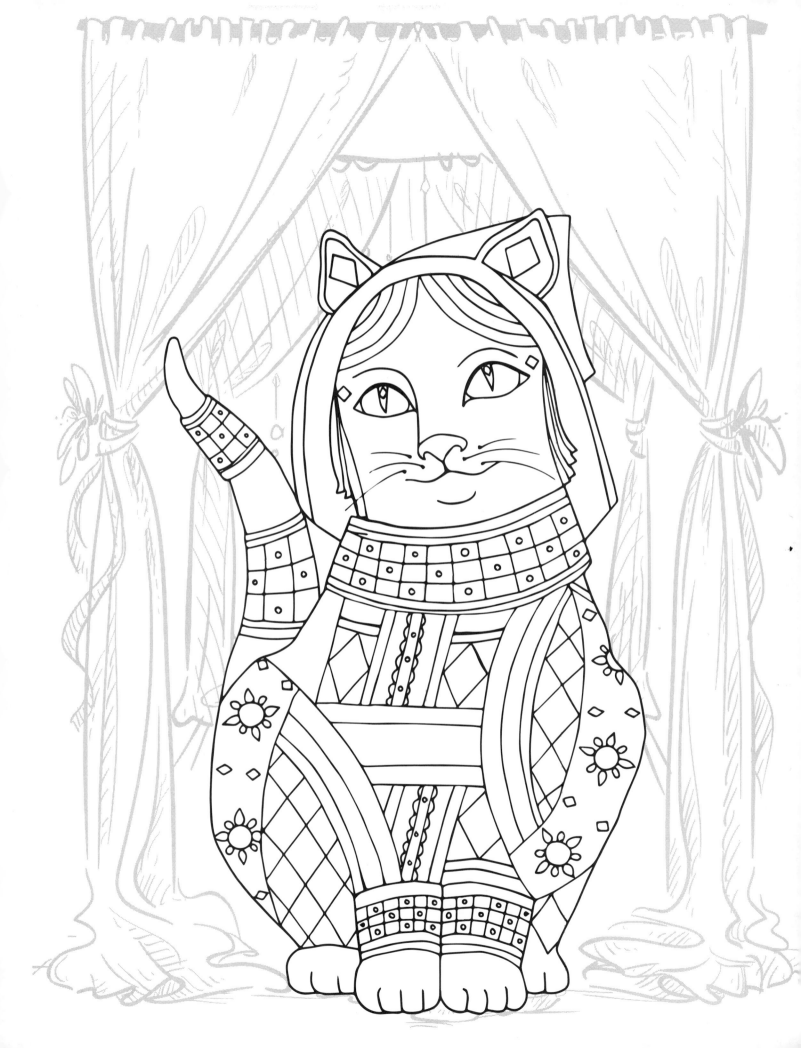

*"A pharaoh's profile, a Krishna's grace,*
*tail like a question mark."*

–Louis MacNeice

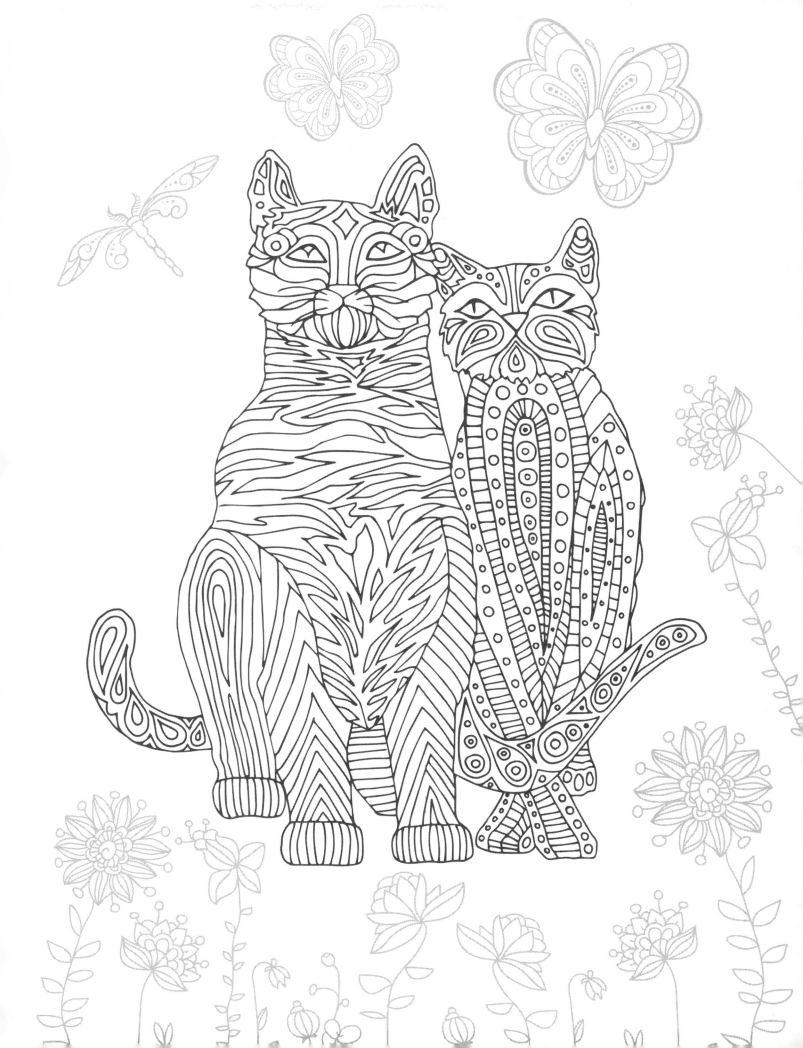

"A kitten is, in the animal world,
what a rosebud is in the garden."

–Robert Sowthey

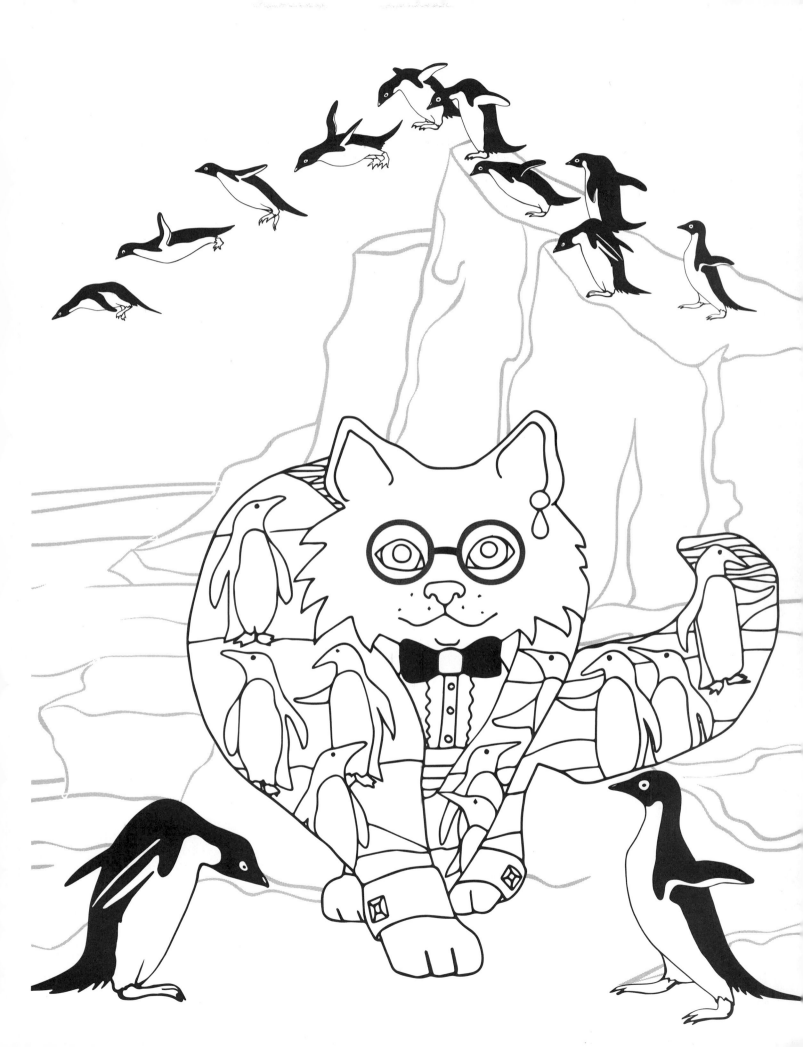

*What are some names you could give this picture?*

_____

_____

_____

_____

_____

_____

_____

_____

_____

_____

_____

_____

_____

_____

_____

_____

_____

_____

_____

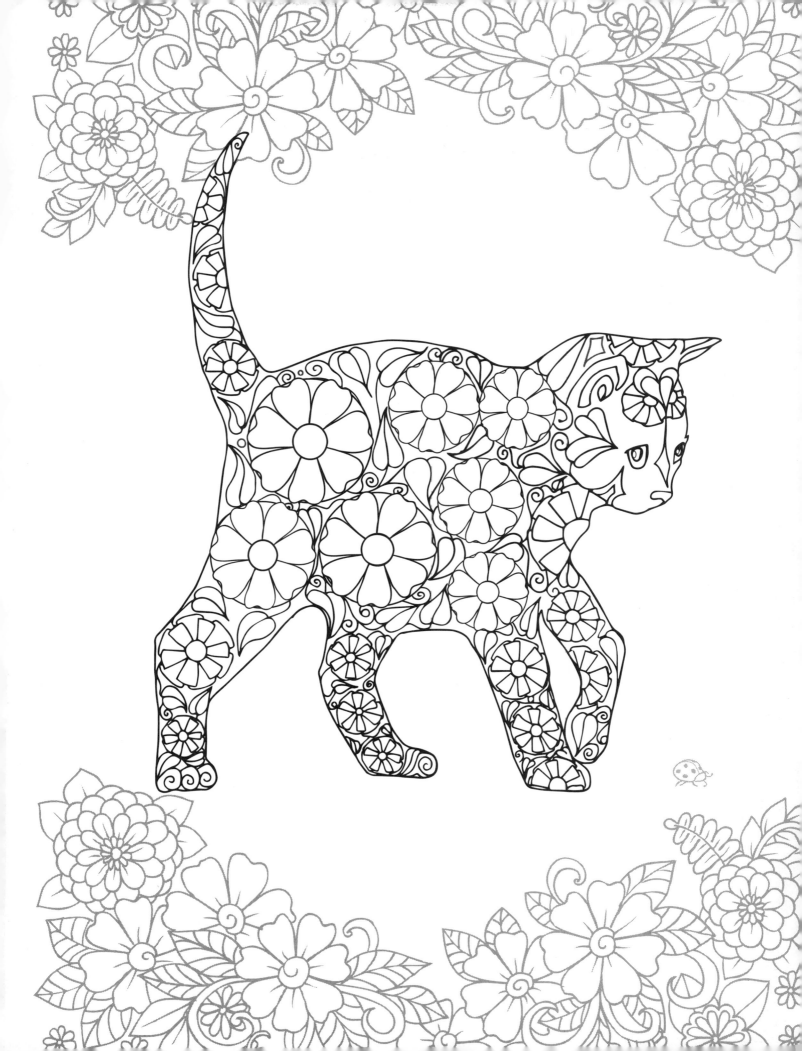

*"The clearest way into the Universe is through a forest wilderness."*

—*John Muir*